IMAGES
of America

MESQUITE AND THE VIRGIN VALLEY

ON THE COVER: In this 1928 photograph, the Samuel Reber family is seen standing in their pomegranate orchard near their home in Mesquite. Pomegranates grow well in the Virgin Valley and were used as a cash crop and for trade in colder climates for products not available in the valley. They can be eaten fresh or made into delicious preserves. Pictured are, from left to right, (back row) daughters, Iva and Leah, and son Clarence with his baby, Clareen, and wife, Ione. Samuel's wife, Mary, stands by him as he proudly indicates one of the ruby fruits. (Courtesy of the Virgin Valley Heritage Museum.)

IMAGES
of America

MESQUITE AND THE VIRGIN VALLEY

Geraldine White Zarate
Virgin Valley Historical Committee

ARCADIA
PUBLISHING

Published by Arcadia Publishing
Charleston, South Carolina

Printed in the United States of America

Library of Congress Control Number: 2009941820

For all general information contact Arcadia Publishing at:
Telephone 843-853-2070
Fax 843-853-0044
E-mail sales@arcadiapublishing.com
For customer service and orders:
Toll-Free 1-888-313-2665

Visit us on the Internet at www.arcadiapublishing.com

*This book is dedicated to my mother, Hazel Pulsipher White;
her mother, Margaret Johnson Pulsipher; and her grandmothers,
Bodil Margaret Jensen Johnson and Ann Elizabeth Bowler
Pulsipher, all pioneers of the Virgin Valley.*

CONTENTS

ACKNOWLEDGMENTS

The Virgin Valley Heritage Museum has proven to be a treasure trove of information, images, and artifacts, and the staff there has been most helpful, especially Pete Clayton, who never let me down when I requested help. His skill and knowledge in locating and scanning the archived photographs sustained my hope that I could complete this book. He also allowed me to use his own photographs of the valley. So much of what I found in the museum is due to the late Verde Hughes, who collected and recorded everything that she thought would be of historical interest to future residents of the Virgin Valley. Museum director Don Montgomery helped me navigate the collection and was a cheerleader for the project.

My profound gratitude goes to two authors for their well-researched histories of the Virgin Valley, which were invaluable in documenting the images I found. They are Dorothy Frehner Thurston with her book *A River and a Road* and Vincent L. Leavitt and his book *Mesquite Flats*. Dorothy was truly gracious, encouraging, and generous with materials that she shared, and I truly enjoyed my visits with her.

Margaret Hardy has been a priceless asset to my research and my attempt to understand the early days of the valley. Having been born here in 1911, she remembers so many of the early settlers, and I loved my visits with her as she has shared these memories.

I am grateful to the members of the Virgin Valley Historical Committee Claudia Leavitt, Gwen Olsen, Valerie Jensen, Cammy Meirhoff, Merlin Hafen, and Don Montgomery for their encouragement and support. Aaron Baker, the committee's liaison with the City of Mesquite, was always enthusiastic about the project and kept me believing in it.

My thanks also go to Jerry Pulsipher, Wilverna Leavitt, Claudia Waite Leavitt, David Bly, Connie Hughes, Rob Faught, and my son John Zarate, who all helped with photographs and information for my research.

I also want to thank all my family, immediate and extended, for their patience and support during this process.

All images used in this book come from the Virgin Valley Heritage Museum, unless otherwise noted.

INTRODUCTION

The Virgin Valley sits astride the Arizona-Nevada state line, with the Virgin River flowing down the middle and the Virgin Mountains bordering on the east and south.

In the eastern part of the valley are two small communities, Beaver Dam and Littlefield, Arizona, and in the western part of the valley is Riverside, a collection of farms and ranches. In the middle on the south side of the river is Bunkerville, a small community with homes, an elementary school, and two churches. Mesquite sits on the north side of the river and is the largest and busiest community in Southeastern Nevada.

This area at one time was claimed by the states of Utah and Nevada and the territory of Arizona. When Nevada was declared a state during the Civil War, it was done in such a rush that the state line in the south was unclear. After much petitioning on all sides, the matter was settled three years later when the U.S. Congress declared that the area was part of Lincoln County, Nevada, which was divided 40 years later to create Clark County.

From its headwaters in Southern Utah's Zion National Park, the Virgin River flows through a small corner of Arizona then into Nevada and the Virgin Valley. Most of the time, it is a small lazy stream that is easy to cross and keep in its banks, but a local storm can send muddy torrents down gullies and desert washes that quickly turn the Virgin River into a swollen, raging flood. Even heavy rain and snow melt in Southern Utah can cause the river to become a destructive force that leaves devastation in its wake. This flooding turned out to be the biggest obstacle in settlement of the Virgin Valley.

Native Americans followed the river in their seasonal migration, and the Old Spanish Trail wound its way from Santa Fe to California along this part of the Virgin River. Explorers like Kit Carson, John C. Fremont, Jedediah Smith, and John Wesley Powell all passed through the valley, but none stayed, and their reports of the area did not encourage colonization.

The first settlers to establish a permanent settlement were families who had been sent to Southern Utah by their church's (The Church of Jesus Christ of Latter-day Saints) president, Brigham Young. They were looking for more land to farm while hoping to continue living the "United Order." They arrived on the south side of the Virgin River January 6, 1877, organized, and committed to live this "Law of Consecrated Property." This meant all goods and property would be held by their bishop and would be distributed according to each family's need. The site was named Bunkerville after their leader and bishop, Edward Bunker.

In 1879, a group of settlers from Southern Utah and Nevada were called by Erastus Snow to settle the north side of the Virgin River and grow cotton for the cotton factory in Washington, Utah. They arrived on the Mesquite-covered flats in January 1880 and built a dam to supply water for their crops, gardens, household washing, and drinking. The summer of 1882 brought a flood

that damaged homes and washed away their dam, ditches, and crops, and by the next spring, many had given up and returned to Southern Utah leaving only the schoolmaster and his wife.

That same year, Dudley Leavitt, one of the original founders of Bunkerville, was ready to move on. His large, growing family (5 wives and over 50 children) needed more land to farm, and the "United Order" effort had not been successful. He relocated across the river, and with the help of at least 10 strong sons, they set about to repair the dam and ditches. With crops of grain, fruits, and vegetables and with cattle, sheep, and pigs, the future seemed assured. But the Edmunds Act of 1882 that outlawed the practice of polygamy and demanded husbands abandon wives and children placed Dudley in danger of imprisonment. When a devastating flood occurred, the family's fate was sealed, and they moved upstream into Arizona territory and settled what they called Leavittville. By 1891, Mesquite Flat was completely abandoned, leaving a few homes and sand filled ditches.

In 1894, a group of young married couples from Bunkerville sought new farming ground and a fresh start. They crossed the river and started work to rebuild the settlement. But their strong young bodies and optimistic outlooks were sorely tested. Every day, except Sundays, they worked on the dam, eating only bread, milk, and molasses.

In the midst of this grueling work-filled spring, a miracle occurred. Three strangers with a team and wagon arrived at the site of the work and introduced themselves as Capt. James L. Smith, Joseph Seatork, and E. R. Cody. They seemed impressed with the hardworking young men and offered to help. These three outsiders soon organized the workers and even financed the purchase of 340 acres at $1.25 per acre. They sent a man and team to Milford, Utah, for fence wire, and a group to the mountains to cut cedar fence posts. After fencing and recording the land, each of the group drew lots for a 15-acre field and home site. The title to the land was transferred to the bishop, and each household then made their payments to him. As payment was completed, the land was deeded to the owner and the monies were given to Captain Smith. The 1896 voting records show the three men were still on the flats, but at some point they offered their holdings for a ride to the train in Moapa, 30 miles away, after which they were never heard of again.

This time, Mesquite was permanently rooted, and newcomers arrived who proved to be industrious with dreams for a growing town. State and county officials seemed only to be aware of the valley's existence when taxes and fees were due, so there was no assistance for medical care, fire suppression, law enforcement, or political governance. After years of paying taxes and fees to Lincoln County, the valley was surprised in 1909 to find Clark County now governed them, but because of a fire at the Lincoln County Courthouse in Pioche, there were no records of deeds or monies paid to be transferred to the new authority.

The isolation delayed change and modernization in the valley, but a post office was established in Mesquite in 1898, a high school was organized in 1911, a grist mill opened in 1916, in 1917 the first long distance telephone line extended to St. George, the first doctor to live and practice in Mesquite came in 1924, the first hard surfaced road to Las Vegas was finished in 1932, U.S. Highway 91 opened through the valley in 1935, the first good drinking water was piped from Cabin Springs in 1938, and Hoover Dam brought electricity in 1939.

The end of World War II brought new prosperity and ever-increasing travel, and the Arrowhead Trail became U.S. Highway 91, which ran right through Mesquite. Tourism, especially in Las Vegas, increased the demand for agricultural products such as milk and eggs, and the farms of the valley filled the market. This caused the size and number of dairies to grow, which soon became the major use of land in the area.

The 1950s and 1960s saw a boom in tourism all over the country, and Mesquite became a convenient place to stop with motels, cafés, service stations, and auto repair garages. In 1959, a tourist complex unlike anything in the valley was opened on farmland adjacent to the busy highway on the west end of Mesquite. The Western Village provided a modern service station/truck stop with trucker's showers and bunks, a large restaurant, gift shop, 22-room motel, and guest swimming pool.

From 1951 to 1962 in the Nevada desert north of Las Vegas, aboveground testing of America's atomic weapon capability was taking place with nearly 100 atomic bombs being detonated. While

official visitors from the Atomic Energy Commission were assuring local residents that everything was perfectly safe and no harm would come to them, their measuring devices placed in the valley were registering high levels of radiation fallout.

With the completion of Interstate 15 from Los Angeles to the Canadian border, travel through the valley increased, and tourism became a business that brought outside investors. In 1976, the Western Village was sold to casino developer Si Redd and became the beginning of the gaming industry in the valley. Golf courses stated to be built, and the housing boom began making Mesquite a destination not just a stopping place.

With growth and development, Mesquite began to chafe under the rule of Clark County government, whose seat was 85 miles away in Las Vegas. Decisions and mandates seemed unfair to the rural areas that had little representation on the county commission. Despite great opposition and dire warnings from officials, the Mesquite Town Board sought to become independent through incorporation in 1983. With dogged determination, incredible energy, hard work, and a sympathetic judge, Mesquite became an incorporated city May 11, 1984.

Mesquite is now bustling with hotel/casino resorts, shopping centers, many housing developments, and golf courses. Creating an area of more than 32-square miles, land acquisitions from the Bureau of Land Management has extended the city's boundaries north to the Lincoln County line and west to the base of the Mormon Mesa.

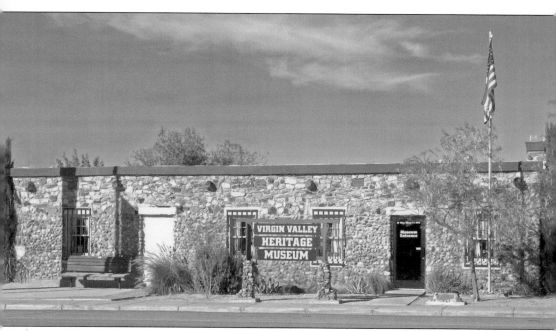

The Virgin Valley Heritage Museum in Mesquite is housed in a rock building erected by local young men with the National Youth Authority in 1941. It is now owned by the City of Mesquite. The museum collection contains artifacts, local and family histories, photograph archives, and newspaper files that help tell the story of the area. Descendants of valley settlers have been generous in their donations of historical items, and the museum is always in search of more. The museum is staffed by the City of Mesquite and volunteers who welcome visitors at 35 West Mesquite Boulevard. (Courtesy of Pete Clayton.)

One

EARLY SETTLERS

The colonizers of the Virgin Valley had a common history. They had been forced to flee their previous homes in the East and were looking for a place so remote and desolate that no one else would want it. Many were related by blood or marriage and hoped to settle near each other. With the arrival of so many immigrants in Utah, settlers were sent to establish a network of Mormon communities in the west, which would eventually extend from Canada to Mexico.

In 1864, the first attempt to settle the Virgin Valley was made at the confluence of Beaver Dam Creek and the Virgin River near present-day Littlefield and Beaver Dam, Arizona. The creek offered better water and a large grove of sheltering cottonwood trees, but those favorable conditions also made the local Native Americans refuse to allow the new comers to stay.

A group of families from Santa Clara, Utah, formed a company and settled on the southern banks of the Virgin River. The Bunker, Leavitt, Crosby, and Lee families were the first to establish the permanent settlement of Bunkerville in 1877.

Another attempt to settle along the Beaver Dam Creek was made the following year. After much hardship, the Frehner family prevailed.

The colonization of Mesquite was attempted three times before a permanent foothold was successful. The first group in 1880 was sent from St. George, Utah, 50 miles up river, to settle the north side of the Virgin River and grow cotton. They left after being repeatedly flooded out. The Dudley Leavitt family also couldn't stay permanently. A third attempt in 1894 was made by young men from Bunkerville. They were William E. Abbott, Abiel Abbott, Don Dunton, John and Vie Hancock, Charles and Heber Hardy, Carlos Knight, Conrad Neagle, Jessie Waite, Abram Woodbury, and Joseph Sealock. This time it was for keeps.

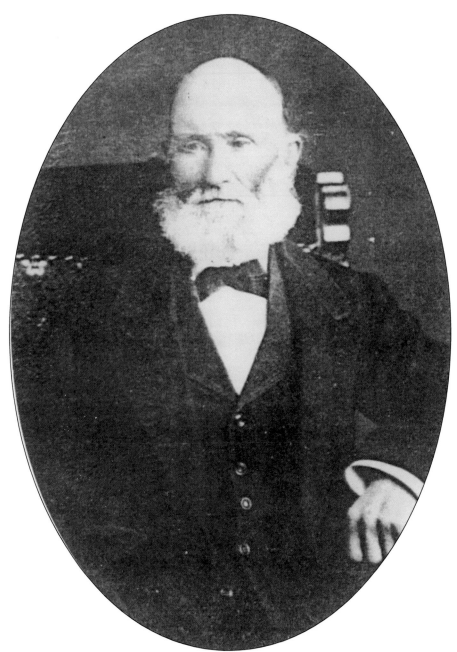

Edward Bunker Sr. led a group of settlers to the south side of the Virgin River in 1877 and presided over them as bishop. Previously, he had marched nearly 2,000 miles with the Mormon Battalion to Los Angeles then returned to Iowa to reunite with his wife and baby. In 1850, they arrived in Utah and settled in Ogden. He was called on a mission to Great Britain from 1852 to 1856, after which he led a handcart company back to Utah and his family. Brigham Young called him to Southern Utah to raise cotton, and from there, he sought expansion further down the Virgin River Basin. The Bunkerville settlers had committed themselves to further the experiment in religious communal living that had failed in their previous town, Santa Clara, Utah. They worked, ate, and prayed together with Bishop Bunker holding all goods and products for distribution as needed.

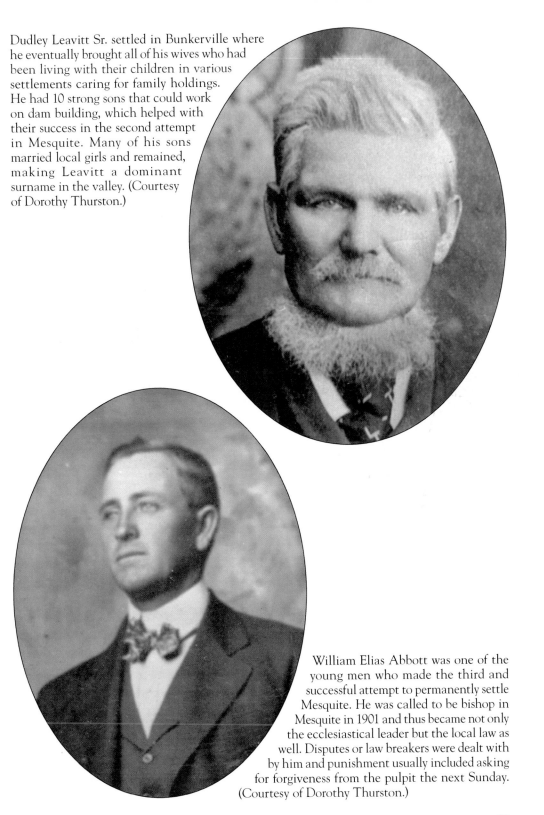

Dudley Leavitt Sr. settled in Bunkerville where he eventually brought all of his wives who had been living with their children in various settlements caring for family holdings. He had 10 strong sons that could work on dam building, which helped with their success in the second attempt in Mesquite. Many of his sons married local girls and remained, making Leavitt a dominant surname in the valley. (Courtesy of Dorothy Thurston.)

William Elias Abbott was one of the young men who made the third and successful attempt to permanently settle Mesquite. He was called to be bishop in Mesquite in 1901 and thus became not only the ecclesiastical leader but the local law as well. Disputes or law breakers were dealt with by him and punishment usually included asking for forgiveness from the pulpit the next Sunday. (Courtesy of Dorothy Thurston.)

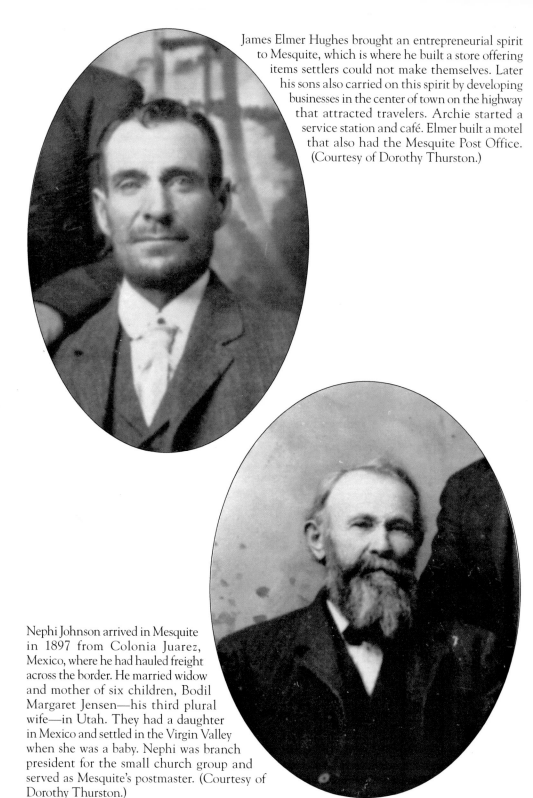

James Elmer Hughes brought an entrepreneurial spirit to Mesquite, which is where he built a store offering items settlers could not make themselves. Later his sons also carried on this spirit by developing businesses in the center of town on the highway that attracted travelers. Archie started a service station and café. Elmer built a motel that also had the Mesquite Post Office. (Courtesy of Dorothy Thurston.)

Nephi Johnson arrived in Mesquite in 1897 from Colonia Juarez, Mexico, where he had hauled freight across the border. He married widow and mother of six children, Bodil Margaret Jensen—his third plural wife—in Utah. They had a daughter in Mexico and settled in the Virgin Valley when she was a baby. Nephi was branch president for the small church group and served as Mesquite's postmaster. (Courtesy of Dorothy Thurston.)

Carmelia Barnum Hardy came from a musical family. Her father and brothers were beautiful singers, and Carmelia played the piano by ear and sang. She married Leo Hardy and was always involved in the musical presentations at church in Mesquite where she played the organ, led the choir, and sang solos.

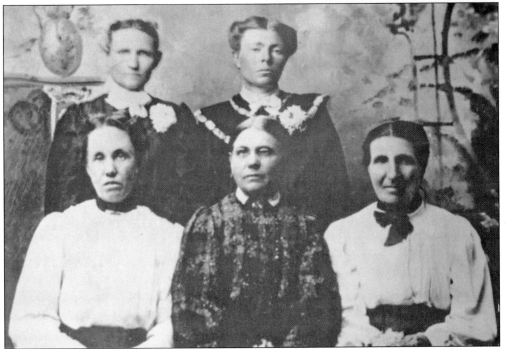

Pictured above are the women who led the Latter-day Saints (LDS) Relief Society in Mesquite, from left to right, (first row) Ann Elizabeth Pulsipher, Bodil Margaret Johnson, Carmelia Hughes; (second row) Lorena Hardy and Mary A. Hughes. Bodil Margaret Johnson was president of this group for nearly 20 years until her death in 1917. They held meetings and classes on activities such as quilting and preserving, cared for the sick, prepared bodies for burial, and served as midwives.

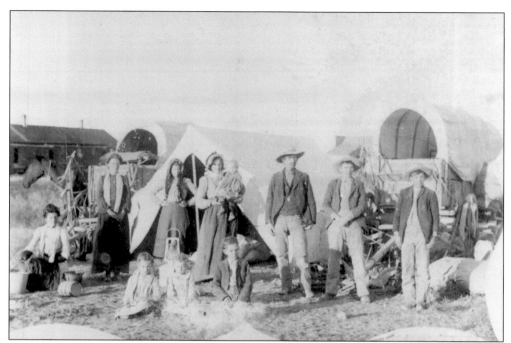

The Joseph Smith Leavitt family came to the valley in 1905. The children on the ground are, from left to right, Ida, Edith, and Heber. Those standing are, from left to right, Eliza, Priscilla, Melvine, Emma with baby Woody, Joseph, Jody, and Hyrum Ernest. They settled and farmed in Mesquite where many of their children married and stayed. (Courtesy of Dorothy Thurston.)

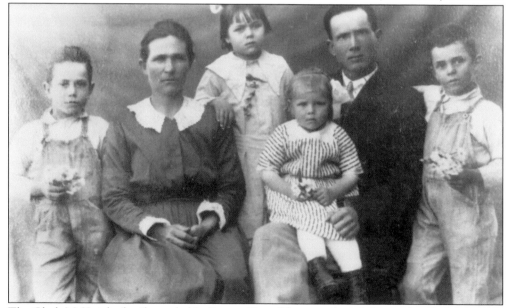

The Clark McKnight family settled in Beaver Dam. They are, from left to right, Carl, Minerva, Thelma, Mable, Clark, and Lynn. The family had orchards of peaches, plums, pears, apricots, apples, prunes, figs, almonds, pecans, and walnuts. Their vineyard had four kinds of grapes, their garden grew corn, carrots, onions, tomatoes, squash, and melons, and their fields grew alfalfa and sugar cane. Cattle and pigs helped make the family self sufficient. (Courtesy of Dorothy Thurston.)

This wedding photograph of Charles Milton and Emma Lorena Leavitt Hardy was taken the month before they helped permanently settle Mesquite in 1894. He had planted a crop of cotton before their marriage, and soon after, they built a house whose living room was used for school with Lorena as the teacher. On Sundays, the room held the first church meetings in Mesquite.

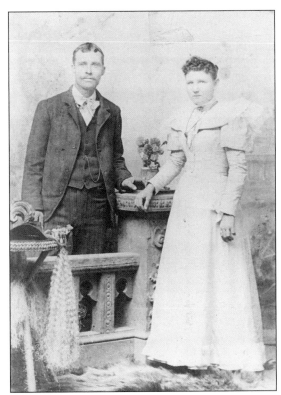

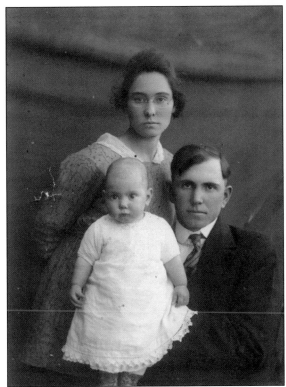

Ralph Huntsman is shown with his wife, Jetta Leavitt, and daughter Iris. Ralph graduated from Virgin Valley High School and went on to graduate from Brigham Young University in Provo, Utah. He returned to the valley and taught art in school and then he went on to teach art at Dixie College in St. George. He was a fine artist and became known for his ability to capture the moods and colors of the Southwest in oil paintings.

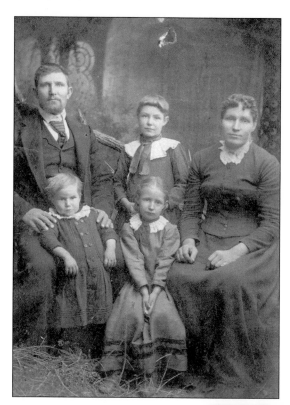

Pictured are, from left to right, (first row) Parley and Alice; (second row) Weir, Ellen, and Idella Hunt Leavitt. Weir and Idella had married when she was 15 years old. During a complicated childbirth, her father rode to summon a doctor from St. George, and though they returned while 33-year-old Idella was still in labor, the doctor was unable to save the mother or baby. Weir lived another 40 years, never remarrying. (Courtesy of Claudia Leavitt.)

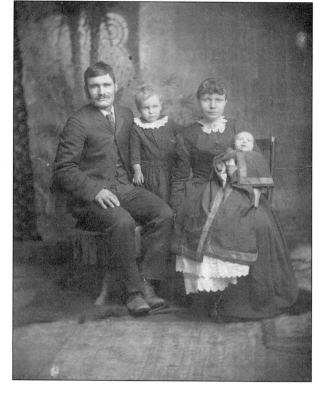

Idella's sister, Udora married Weir's half brother, Alonzo. He narrowly escaped death at a salt mine, and after this photograph was taken, his right arm lost the ability to function because of an accident at the Bunkerville flourmill. He was pulled into the heavy rollers, and his arm was crushed. Pictured are, from left to right, Alonzo, Ralph, Udora Hunt, and Roxie Leavitt. (Courtesy of Claudia Leavitt.)

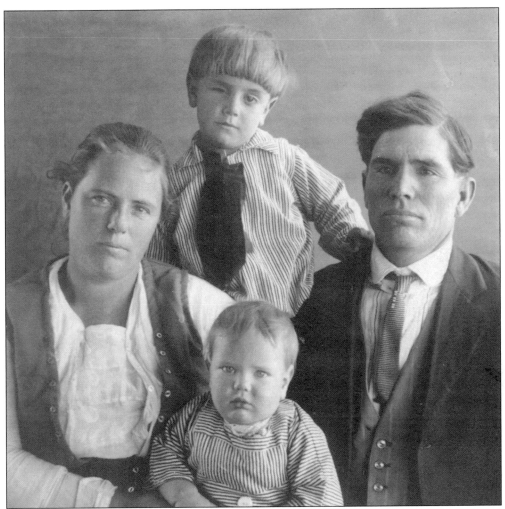

Ira and Josepha Abbott Leavitt are pictured here with their two young sons Curtis (top) and Clawson (bottom). This family suffered tragedies that illustrate how the lack of medical help affected the valley. Many of the injuries and illness might have been lessened and lives saved, if medical help had been more available. The father, Ira was crushed while standing on a running board of Bishop Abbott's car that was sideswiped by an orange truck from California. The driver did not stop, and Ira died before getting to St. George for medical help. Josepha later married William Jones, and she died after being gored by a cow with a calf in its corral. Curtiss had an eye that was blind and later lost the use of the other eye. The other little boy, Clawson grew up in the valley and married Clareen Reber (the baby pictured on the cover of this book). (Courtesy of Dorothy Thurston.)

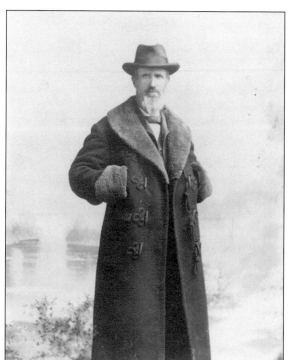

Shown here in 1887, Joshua Sylvester made his home in the Virgin Valley just across the Arizona border from Mesquite in 1897 near Nephi Johnson, who had been a friend in Utah, and his family. The area of their homesteads was a favorite gathering place for the people of Mesquite to come for holiday picnics and celebrations because of the shady grounds, gardens, and the delicious melons that were grown and shared.

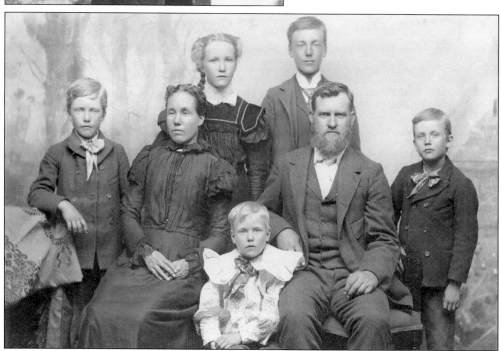

The John David and Ann Elizabeth Pulsipher family moved to Mesquite in 1900. Pictured are, from left to right, (first row) Howard; (second row) Stanley, Ann Elizabeth, John David, Ernest; (third row) Florence and John Lewis. John David had been advised to move to a warmer dryer climate for the health of his lungs, which were damaged from work at the Delamar Mine in Nevada. (Courtesy of Jerry Pulsipher.)

20

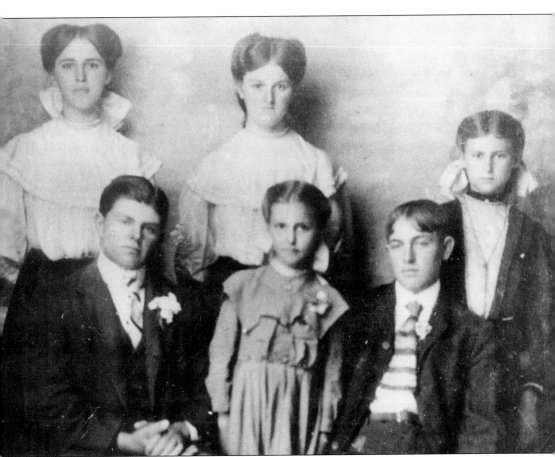

The children of Henry and Henrietta Frehner of Littlefield pose for a c. 1907 photograph. Pictured are, from left to right, (first row) Joseph, Erma, Alfred; (second row) twins Minnie and Millie with younger sister Lillian. At this time, they had survived the death of two small brothers and another brother who died at age 17 to typhoid. About a year after this photograph was taken, measles swept through Littlefield and took 17-year-old Millie. Seven months later, twin Minnie, weakened from a serious illness and the grief of her sister's death, asked her best friend Mable Leavitt to sing at her funeral. Despite her valiant effort, Mable collapsed as she tried to honor the request and was unable to speak for several weeks after Minnie's death. (Courtesy of Dorothy Thurston.)

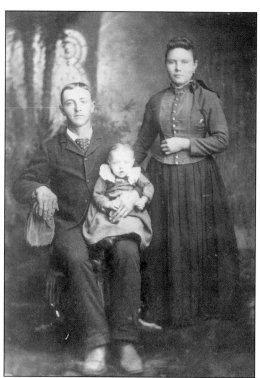

William E. Abbott is shown about 1891 with his wife, Mary Jane Leavitt Abbott, and Abigail Christina, the first of their 13 children. It was common at that time for married men to be called on missions, and in 1896, he left for 25 months. He sold most of his property to finance his mission and support his family while he was gone. After returning, he spent two years working to reestablish his family's finances. (Courtesy of Dorothy Thurston.)

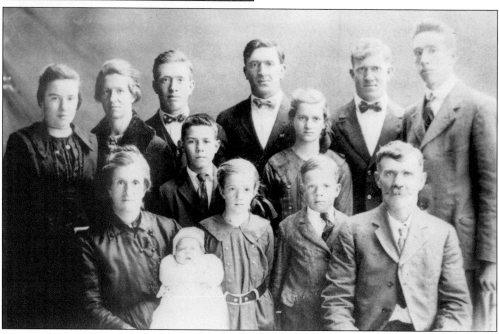

Mary and Samuel Reber had 13 children, which included three sets of twins, but lost two babies in infancy. In the photograph, they are, from left to right, (first row) Mary holding Caroline, Iva, Ira, Samuel; (second row) Leonard and Leah; (third row) Lida, Julia, Clarence, Arthur, Clyde, and Ralston. They had first settled in Littlefield, but when a flood destroyed their crops they bought a small house and floated it down river to Mesquite. (Courtesy of Dorothy Thurston.)

In a valley that depended a great deal on their horses and wagons having a blacksmith shop was very important. Wheel rims and horseshoes were wrought by John Henry Barnum at his forge and blacksmith shop near the river bridge where it was convenient to both towns. This photograph shows him with his wife, Alameda, and their baby, Dellas. (Courtesy of Dorothy Thurston.)

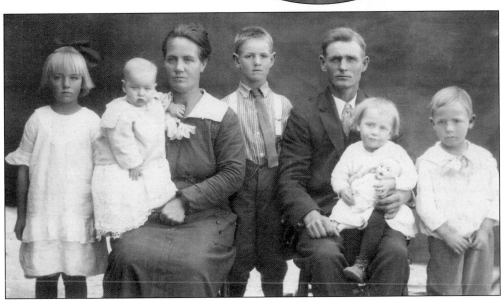

The John and Christine Abbott Jensen family are, from left to right, Myrtle, Derald, Christine, La Von, John, Gussie, and Altis. John had extensive fields on the western edge of Mesquite. They eventually had 14 children, 3 of whom died very young. Their 5 sons helped with the farm, cattle herd, dairy, and turkey flock. (Courtesy of Dorothy Thurston.)

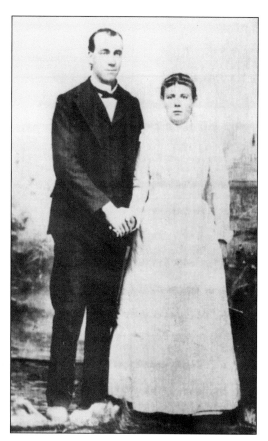

Charles Arthur Hughes and bride, Orilla Leavitt, were photographed at the time of their marriage, December 11, 1900, in St. George, Utah. They farmed, started a dairy business in Mesquite, and lived in a one-room lumber home until their 12th and last child was born. (Courtesy of Dorothy Thurston.)

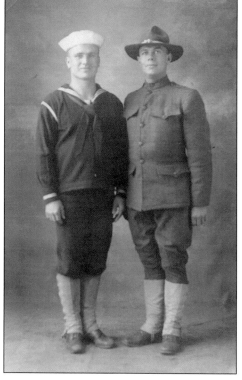

Cousins, Austin (left) and Orval Abbott (right) joined the military at World War I. Though the Virgin Valley's population was small they sent their share of young men to war. During World War I, 13 young men served, and during World War II when the population of the entire valley was about 800, nearly 150 young men joined the armed forces. (Courtesy of Dorothy Thurston.)

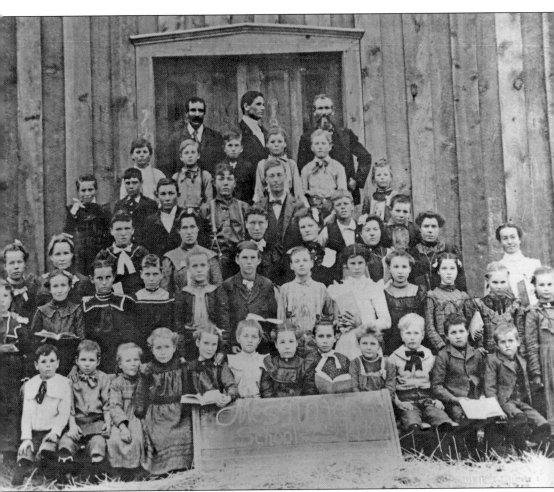

This photograph taken February 21, 1902, shows the students of the one-room rough-lumber building where they went to school in Mesquite. This was built in 1899 near the southwest corner of today's Mesquite and Sandhill Boulevards. The lumber had been hauled from a sawmill in the mountains east of Mesquite, and the whole town helped to construct this school, which would also be used for church. There was a great range in ages from the first to the eighth grade, and one teacher taught all the students. In the group are older children who would soon need to leave school to help their families in their struggle to survive. Few students were able to attend more than a few years. The one-room schoolhouse was approximately 20 by 30 feet and had 12-foot-long planks that were used as writing desks with rough benches to sit on. On the back row are, from left to right, school trustee James Elmer Hughes, teacher Frank Cox, and trustee James Hughes.

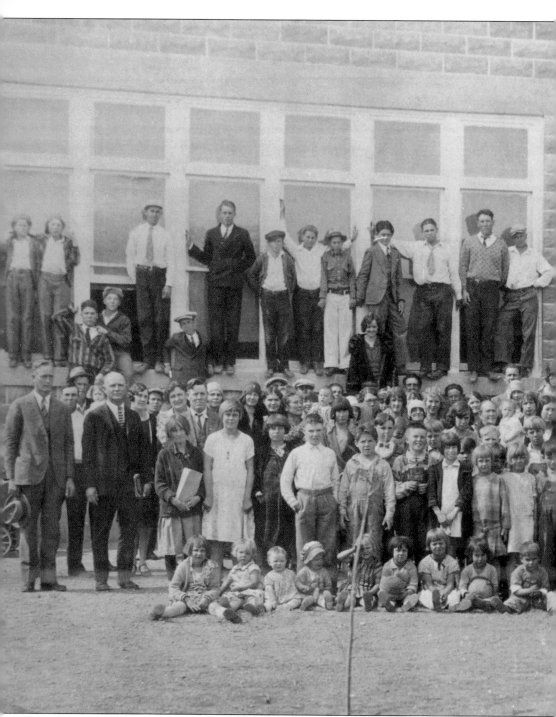

This c. 1930 photograph shows the Mesquite Elementary School auditorium with the Mesquite Ward of the Church of Jesus Christ of Latter-day Saints standing in front. Howard Pulsipher, bishop is seen standing at the far left. The church paid the school district $24 a month to use the build for its meetings. The same arrangement was used in Bunkerville. During the school year, the building was almost in constant use with after school church programs for children

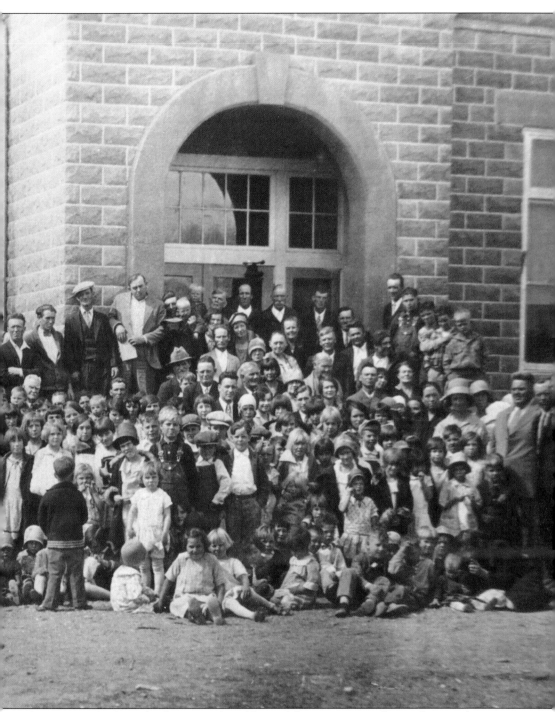

and young people, funerals, dances, and wedding celebrations. Since the residents at this time were all members of the church, this helped to save on their resources, as the small towns could not afford to build separate buildings for the different functions. The small trees planted in the lawn are mulberry trees that grew into very large sheltering trees and were enjoyed by the schoolchildren for many years. (Courtesy of Dorothy Thurston.)

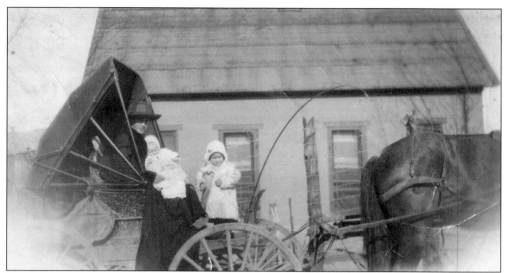

Margaret Pulsipher with children Zella and Lewis sits in front of their home in a black top buggy that was used to visit her parents who lived just over the Arizona state line and for trips to town for church or shopping. Margaret felt somewhat isolated on their ranch, which was located on the present day Casa Blanca Golf Course. When their children were older, the family moved to town so they could attend school. (Courtesy of Jerry Pulsipher.)

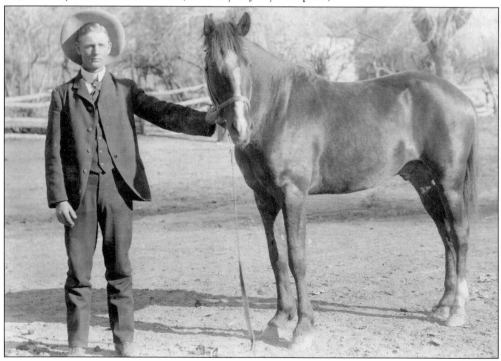

In this photograph, John Jensen proudly shows his horse Snip. Like others in the valley, he was proud of owning a fine horse and enjoyed racing it. Horses were very important in the valley for transportation and labor on the farms. Automobiles were slow to be used in the valley but slower still were gasoline driven farm machinery, so horses remained features on local farms for many years. (Courtesy of Hazel White.)

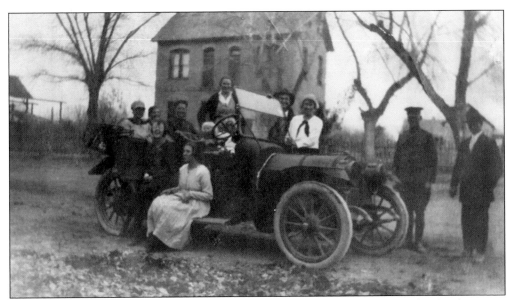

Well-known author and historian Juanita Leavitt Pulsipher Brooks is believed to be the young woman shown sitting on the running board of a car in front of the Thomas Leavitt house in Bunkerville during World War I. Her preservation of pioneer journals and research of early Southwest settlements are recognized as priceless contributions to the recorded history of the West. (Courtesy of Dorothy Thurston.)

Hubert and Libby Leavitt (with dog Shep) are seen standing in front of their Mesquite home. Between 1910 and 1912, Hubert built the first telephone system in Mesquite, which had lines between homes and even some to Bunkerville and Littlefield. He did this by stringing wire on fence posts and mesquite bushes and using old bottles as insulators. (Courtesy of Dorothy Thurston.)

John Lewis Pulsipher was serving as a young Mormon missionary in San Francisco on April 18, 1906, when the great earthquake struck. Using his pioneering experience and skills learned while sheep herding, he helped fellow evacuees survive in Golden Gate Park by cooking over campfires and living in the open. His mission was cut short by a reoccurrence of malaria contracted in the Virgin Valley. (Courtesy of Jerry Pulsipher.)

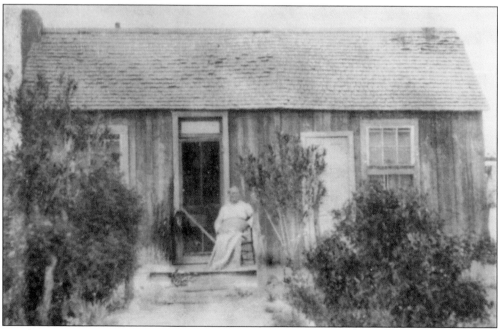

Martha Ann Barnum was photographed about 1900 in front of her son's house in Mesquite. She later moved to the rock house, which still stands in Mesquite, and lived there while taking in washing for support until she died. She was the first plural wife of James Barnum and, after he married his second wife, preferred living separately. (Courtesy of Dorothy Thurston.)

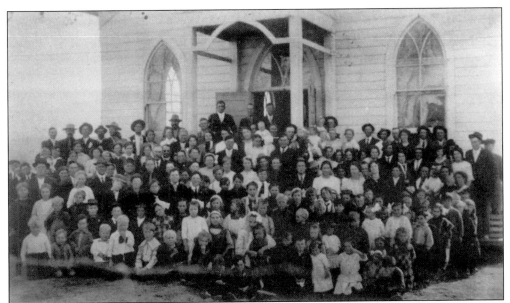

This photograph shows the congregation at the White Steeple Church in Mesquite. The design of this building made it the first church building in Mesquite to look like a church. Previous buildings were multifunctional and were built looking more like schools. The gothic arched windows and the white painted exterior gave it a dignified appearance. The building had one large room with a stage at one end with curtains that could be drawn for presentations.

Shown here at the age of 18, Jody Leavitt would later be under contract to pull vehicles across the river with his team of horses. He had a farm near the river and kept his horses corralled nearby. At times, he would be using his team in his fields when the signal would come that his horses were needed and he would leave his work to assist. His wife, Cora, would take the team and assist travelers when Jody was not at home.

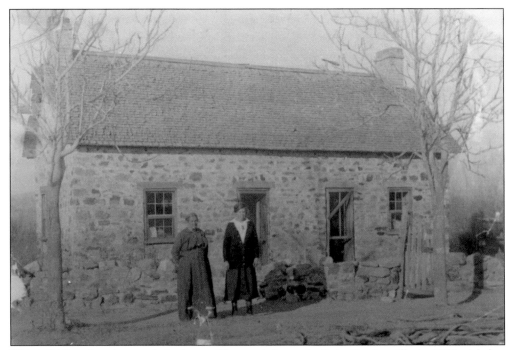

Thirza Riding Leavitt stands in front of her rock house built in Bunkerville in 1890 with her daughter Elfonda. Married when she was 16 years old in 1859, Thirza was the third plural wife of Dudley Leavitt, and they had eight children. All of Dudley's wives maintained separate homes with their own gardens and milk cows and each corded and wove their own cloth. (Courtesy of Dorothy Thurston.)

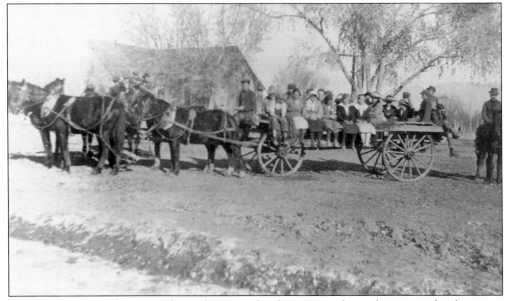

This 1916 photograph shows a hay ride, a popular diversion and social occasion for the young people of the valley. There were always wagons and teams available, and the ride would include group singing, courting, and picnics with young married couples, invited as chaperones. Sometime the rides would end with bonfires or at someone's home for games.

Howard Pulsipher came to the valley as a boy in 1900. In 1923, he built a garage to repair cars. He remembered how he "rigged up a way to use the gasoline-driven compressor to run the generator and furnish enough lights for the office and around the hand driven gas pump." His family is, from left to right, (seated) Myrtle, Stewart, Lucille, and Howard with Bernice standing.

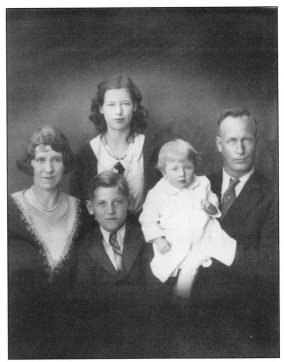

The George Edward Granger family was photographed in 1918. They are, from left to right, (first row) Cyril and Walter; (second row) Archille, George, Clara Stewart Bauer Granger; (third row) Urban Horatio and Myrtle Stewart. The family built several businesses serving the needs of travelers that expanded as the town grew.

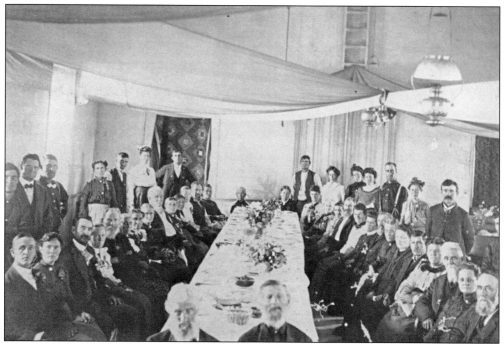

The Old Folks Party held in about 1905 shows most of the early settlers gathered to be honored by the valley. Dudley Leavitt and his five wives are seated, starting seventh from the left, Mariah, Mary, Dudley, Thirza, Janet, and Martha Leavitt. They are gathered in the rock church in Bunkerville, and the factory cloth ceiling and the ladder to the belfry can be seen.

Margaret Bodil Johnson was the daughter of Nephi Johnson and lived on their ranch across the Arizona state line to the east of Mesquite. She would sit astride her pony when riding to town until she reached the point where she would be seen. She would then swing both her legs to one side continuing on in the more lady-like sidesaddle style. This photograph was taken at the time of her marriage to John Lewis Pulsipher in 1910. (Courtesy of Jerry Pulsipher.)

Two

STRUGGLE TO SURVIVE

To this isolated desolate area, no one brought wealth or huge ambitions for wealth. When they arrived, the first issue that had to be addressed was the task of damming the river and building a canal so that ground could be leveled for fields and crops could be planted. In each community and at each attempt, they lived in makeshift shelters until the towns could be laid out and home sites established. The river was also the only source for drinking water, but the mud in the barrels often took 12 hours for it to settle enough to make it drinkable. Sometimes milk was even added, and the barrels were wrapped in wet burlap to help cool and settle the mud.

Homes were constructed from available materials, usually rocks or mud in the form of adobe bricks until lumber was brought from distance sawmills. The houses were no larger than needed and had little adornment.

Church and school were held in a tent, under shade trees, in homes, a brush covered bowery, and rock or lumber structures later on. Everything that was needed had to be hand made, grown, or built.

Another use for the canal was realized when its water power was used to run a flour mill that ground locally raised grains into flour during the years of World War I. It was a time of shortages but the mill produced all the flour the valley needed, and they were able to ship it to places that were in need.

The intense heat, disease carrying insects, and brackish water were facts of life and not soon to be remedied. The great distances to the "outside" could not be shortened. They just had to survive, make a life for their families, and hope for better tomorrows.

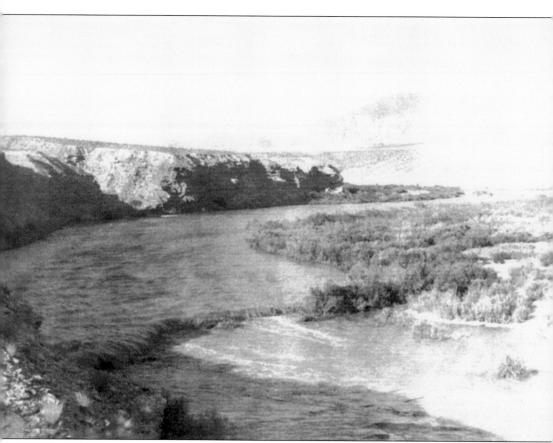

Maintaining the water flow into their canal required almost constant labor. Layers of large rocks and brush were used to divert the river water into the six-mile long Mesquite canal and the nearly three-mile Bunkerville canal. The huge flood of June 28, 1882, that spelled the doom of the first attempt to settle Mesquite washed out their canal in 58 places taking crops and "carrying everything before it of a movable nature." Women and children were taken to higher ground, and the men fought to keep the water away from buildings. Conditions at the dams were always hazardous as when 12 out of the 21 men struggling to repair the dam that summer came down with malaria in temperatures that were reported to be 140 degrees where the men were working. While a dam was being repaired, the planted crops had to be watered by hand often for weeks. Wagons loaded with barrels hauled river water to the fields while also providing household and drinking water.

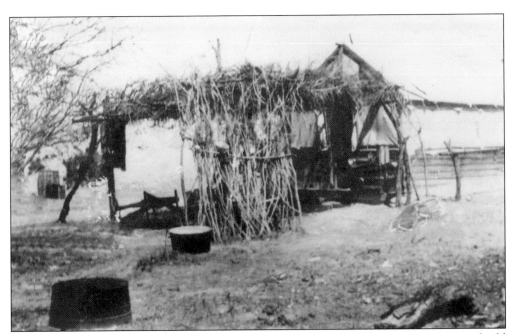

Shelter was important to the early settlers, but most did not have the means or time to build homes at first. Temporary shelters consisted of wagon boxes, dugouts, tents, and boweries. Local materials, such as brush, cactus spines, and rocks, were incorporated to construct some protection. (Courtesy of Dorothy Thurston.)

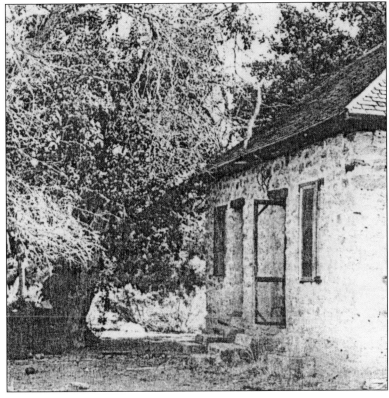

While building this rock house near Beaver Dam Creek, the McKnight family lived in a tent with lumber sides. The first settlement in the Littlefield/Beaver Dam area was in 1864, which was called Millersburg after Henry Miller, but was abandoned when a flood on December 23, 1867, completely swept crops, animals, orchards, equipment, and homes down river. (Courtesy of Dorothy Thurston.)

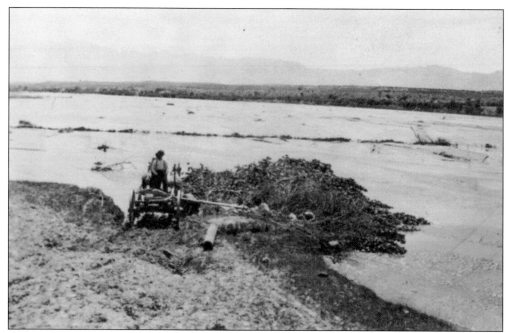

Entire cottonwood trees were cut down and dragged by teams to the river, which can be seen in this photograph taken prior to 1921. They were used to build weirs that diverted the water into the canals. This method worked better than using brush and rocks, but trees were scarce in the valley and had to be planted and allowed to grow to sufficient size.

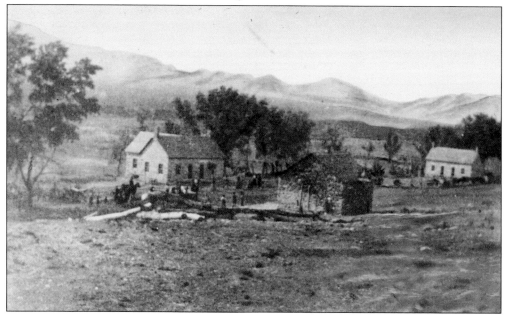

Littlefield, Arizona, is situated near the confluence of the Beaver Dam Creek and Virgin River, where the first attempts to settle and farm in the valley were made, but floods and conflicts with the Native Americans made the effort to settle there difficult and not successful until 1878. Pictured are homes and the rock schoolhouse, which can be seen in the center foreground of the photograph. (Courtesy of Dorothy Thurston.)

This home was built by Charles and Lorena Leavitt Hardy who came to Mesquite in 1894. Two weeks after they were married, he went to the mountains to get lumber for the roof of their adobe house they were building, and she stayed in Bunkerville in a shed behind her sister's house. This house was enlarged until in the 1920s, which was when it was one of the largest houses in town.

Smokey Lane in Mesquite is shown in the early 1960s with cottonwoods that may have started as fence posts. Often posts were "green cut" from living trees and placed on ditch banks, which ran along property lines and roads. Cottonwoods were valued for their fast growth, which created cooling shade and firewood. Some roads in the valley were almost tunnels of cottonwoods. (Courtesy of Jerry Pulsipher.)

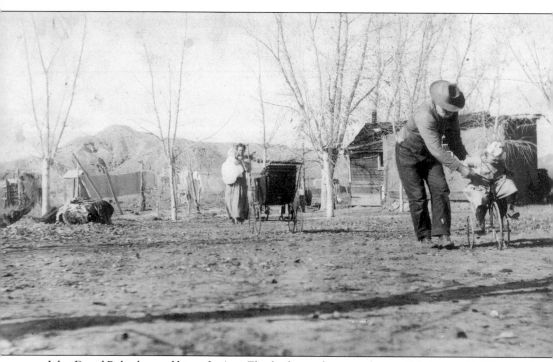

John David Pulsipher and his wife, Ann Elizabeth, are shown with two of their grandchildren at the home of their son Lew. During the school year, they would trade their home across the street from the school for this house on the far west edge of town so that their grandchildren could attend school. The sand hill seen in the distance was known as Cougar Hill. (Courtesy of Jerry Pulsipher.)

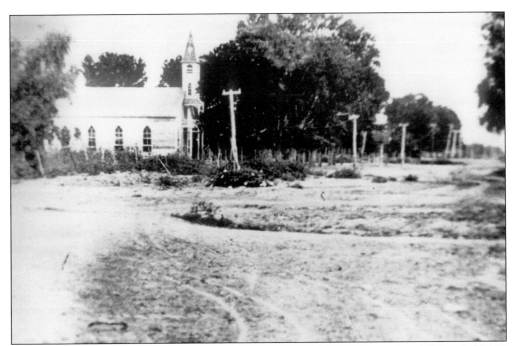

Referred to as the White Steeple Church, this lumber building was erected in 1909 with $1,000 from the headquarters of the LDS Church and donated labor from members in Mesquite. It had arched windows and a steeple with a bell that rang to summon the congregation at meeting times. This photograph taken in about 1915 looking west shows the condition of the road that would become Mesquite Boulevard.

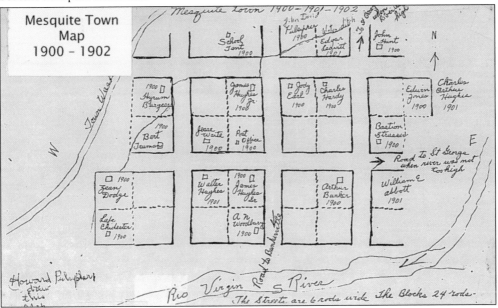

Howard Pulsipher drew this map of Mesquite as it was laid out when his family arrived. Mesquite Boulevard now follows the street one block north of the river and turns into Sandhill Boulevard at the corner of the Abbott and Strasser properties. The town blocks had been divided into quarters with room for homes, animals, and gardens.

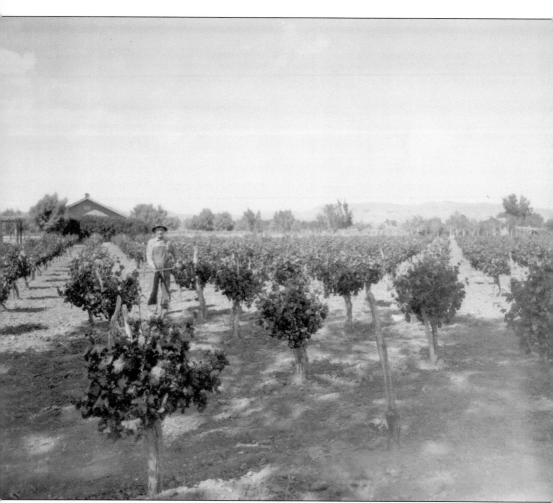

Samuel Reber is shown standing in the vineyard that he owned with Alfred Tobler. Grapes grew well in the valley, and the soil and climate were an advantage that many families used to produce their own grapes of high quality. Growers sent entries to the World's Fair in San Francisco, and local legend says their faith in the crops' quality was rewarded when the Thompson Seedless raisins and pomegranates won first prize in their categories. The year was believed to be 1906, but research suggests it was three years later in 1909.

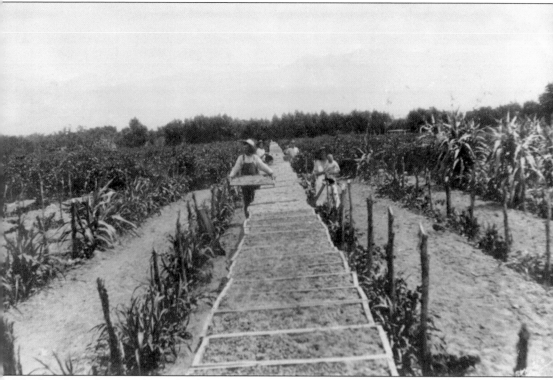

The long line of trays in Samuel Reber's fields holds grapes spread in the sun to make raisins that were boxed in 25-pound containers and then shipped to market. The Rebers had 350 trays that consisted of wooden framed wire screens, which allowed air to circulate through the drying fruit. The grapes were spread for eight days in the sun, then turned, and left for three days more. Five pounds of grapes yielded one pound of raisins, which sold in the 1920s at about 8¢ to 10¢ a pound. Many families raised grapes and made raisins for their own use. Raisins mixed with parched corn were a favorite treat for children in the valley where candy was very scarce.

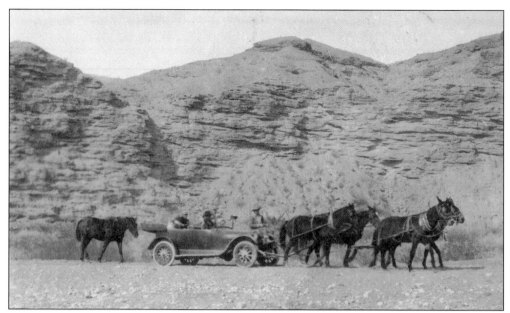

Southwest roads typically were often through soft deep sand that could bog down travel. When automobile drivers found they did not have the power to navigate through this problem, teams of horses often accompanied travelers across these areas or were borrowed for particularly difficult stretches. (Courtesy of Jerry Pulsipher.)

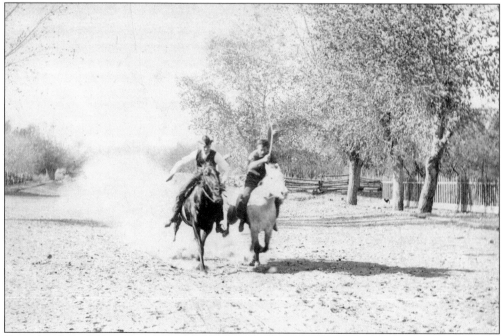

Some families in the valley maintained fast ponies that were used for racing at special events. In 1915 at Christmas time, visitors from Gunlock and Enterprise, Utah, and Moapa Valley, Nevada, came and spent two weeks visiting and participating in horse races, nightly dances, dramatic productions, foot races, and baseball games with competition between towns. This photograph shows a match between two ponies racing down the main street of town. (Courtesy of Hazel White.)

This two-story house in Bunkerville was built in 1883 and owned by Cull Leavitt until 1913. Later Henry Leavitt owned the house until it burned in 1933. Materials from the burned building were used to build a smaller house. (Courtesy of Dorothy Thurston.)

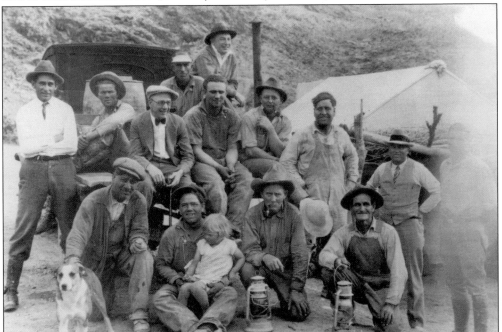

A plan in 1929 to build a dam at the beginning of the Virgin River Narrows involved dynamiting the rock cliffs to fall and fill the canyon mouth bringing the water level high enough for a canal south to the slope of the Virgin Mountains. When partially finished, a huge flood burst the dam, sending destruction down the river. The company left owing a great deal of money that was never paid. This photograph shows the local crew at the site.

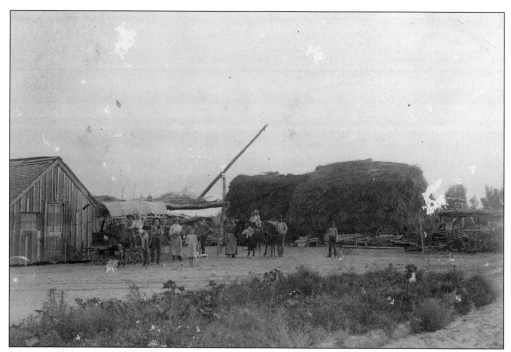

The Reber family haystacks are shown with their first home and farm yard in Mesquite. This typical farm yard shows the tall wooden derrick used to handle heavy loads by utilizing a long pole with a counter balance on the end.

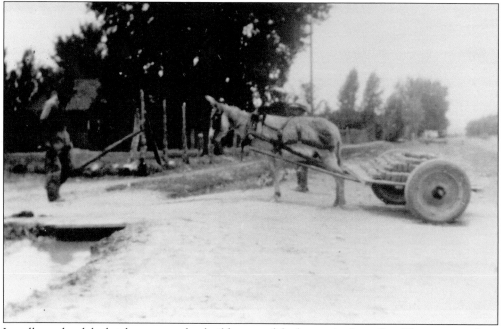

Locally made adobe bricks were used to build many of the homes in the valley. They were made at the adobe yard, which was also the town square and site for the first tent school at the northwest corner of Willow and First North Streets. Shown above is Al Wharton's donkey-drawn cart delivering adobe bricks to a building site in Mesquite.

This small building constructed in 1935 in Mesquite was headquarters for an egg co-op that was organized in 1929 to help market the valley's eggs to buyers outside the valley. As Las Vegas grew, the demand for fresh eggs enabled local families to begin raising flocks of chickens to produce eggs. Eggs in large quantities were also needed for local cafés, hotels, and campers.

Two schoolteachers are shown drinking at the "school drinking fountain." They are sisters Hazel Kepley who taught first and second grades and Ethelyn Kepley who taught third and fourth grades. The house, which was not near the school, seen in the background is that of David Abbott, so it can be assumed the young women are spoofing for the camera. The practice of drinking directly from the ditch was not uncommon for children.

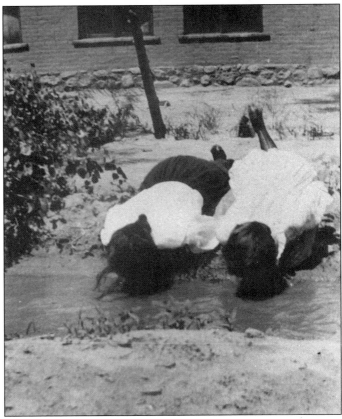

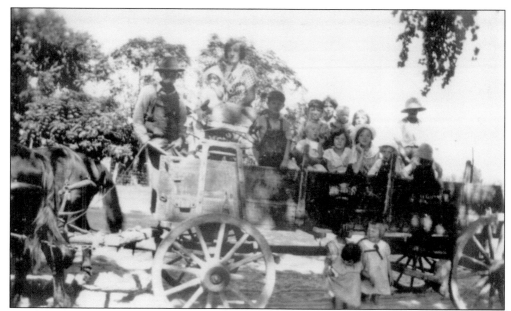

Henry Frehner is shown giving his grandchildren a Christmas Day wagon ride. Henry first came to the valley in1878 and staked a claim in Littlefield with others but he was the only one to remain. Living alone for a year and a half, he persevered, until family members and others came to establish the second permanent settlement in the valley. (Courtesy of Dorothy Thurston.)

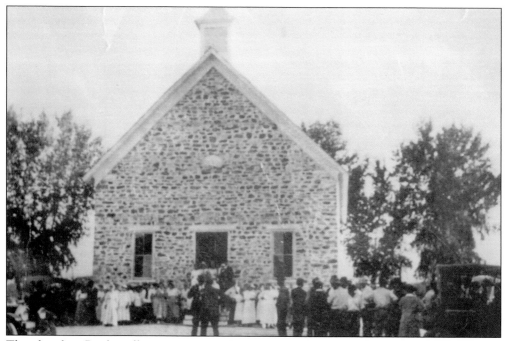

This church in Bunkerville was constructed in 1900 of native rock and was a great improvement over the small rustic structure it replaced. The interior was 75 by 100 feet and had a stage and rooms for individual classes so that it could also serve as their school. The church also was used for a dance hall that could finally hold the large crowds that loved to attend regular dances.

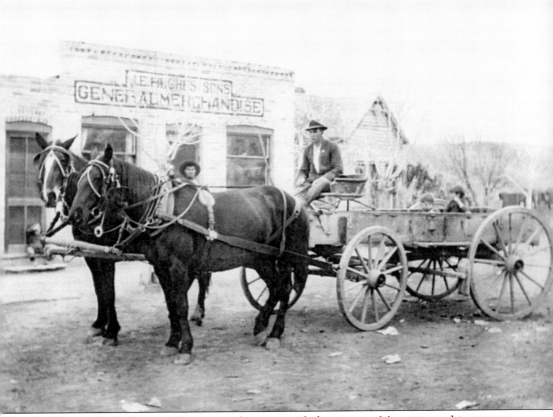

In 1904, James E. Hughes and Sons started a mercantile business in Mesquite, and inventory had to be obtained from many sources, locally and regionally. As the business grew, James began bringing in merchandise by train. In this photograph, James is seen in front of his store on the wagon used to haul the shipments from the train station in Moapa. Just beyond the store can be seen the family home facing Willow Street. As automobiles became increasingly more popular, he also sold gasoline in five-gallon cans because he didn't have a gas pump. When traffic increased in 1926, the store was moved a few hundred feet south to face the main street, which is now Mesquite Boulevard. Samuel Crosby in Bunkerville had started the first store in the valley in the late 1880s. It was operated from a long room attached to his home. Before this time, residents had to grow, make, or build whatever they wanted or needed.

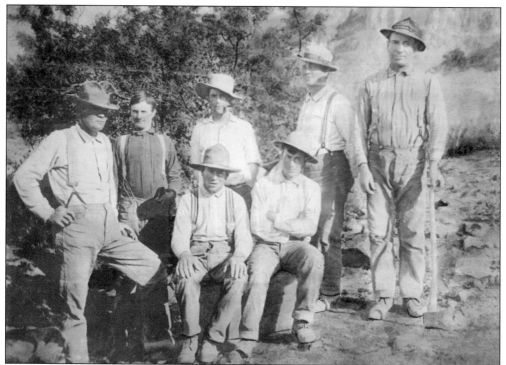

This photograph shows local men who were working at a lead mine owned by Zilpha Hughes in the mountains southeast of the valley in 1916. They are, from left to right, the following: (first row) George Burgess and Willis Guearo; (second row) Edward Cox, Wallace Woodbury, Matt Reese, William E. Abbott, and James E. Hughes. Though it was a very rich vein, it turned out to be too costly to mine and haul out.

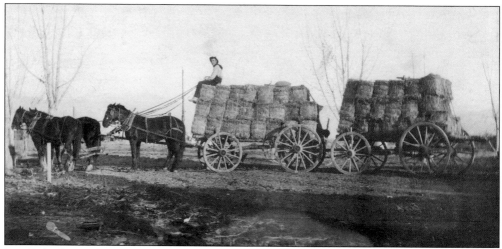

Lew Pulsipher is shown in 1915 preparing to depart with a load of hay. He and his father John David purchased a new baler and teams with wagons to haul the bales. After delivering half of the agreed amount of hay to the dam project at the Beaver Dam narrows, Lew discovered that he was being paid with bad checks. The project was destroyed by flood, the company left town, and the family was left with $1,500 owed to them. It took the family some time to recover financially. (Courtesy of Jerry Pulsipher.)

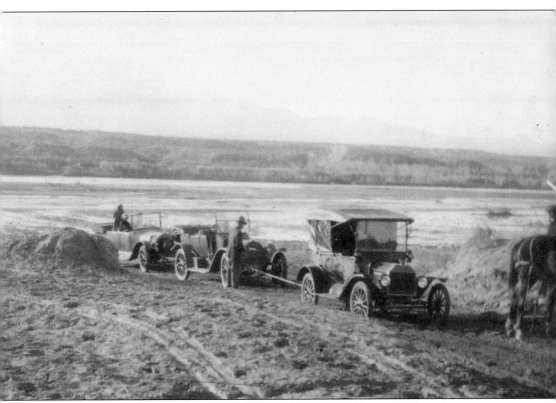

Three autos are shown being pulled across the river by a team of horses. When there was not much water in the river and there was not a lot of deep mud, cars would drive down the river on the damp sand, which made a firm roadbed. They would then exit the river bed where ever it was convenient and continue on to join the road. When the water was high, the automobiles resembled boats as they crossed being pulled by horses. Jody Leavitt had the contract to use his horses for crossing. He was gone one day when his wife, Cora Leavitt, helped Senator Henderson and Governor Boyle cross the river. They apparently did not believe her when she warned them not to turn the engine on until they were safely across and unhitched from the team. The startled animals ripped the bumper right off their large automobile and left them and their car in the river. (Courtesy of Jerry Pulsipher.)

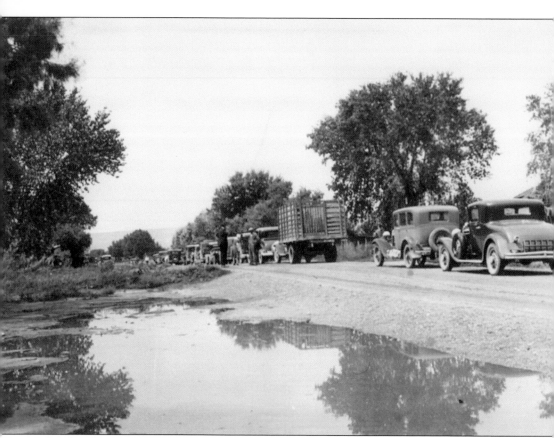

Washes that ran from sand hills north of Mesquite through town to the river were not bridged, which created dips in the road. When flash floods came down, these washes made crossing impossible, and traffic would stop as in this photograph, which was taken around 1931. This photograph shows Mesquite Boulevard going west with a line of cars waiting for floodwater to recede.

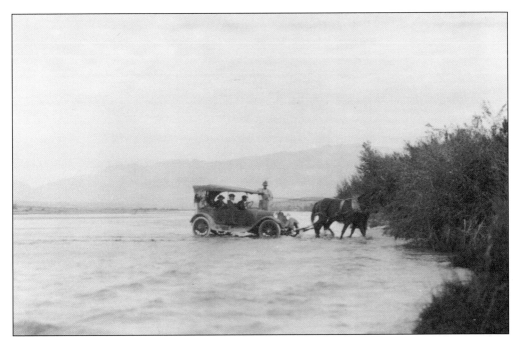

Historian Karl Larson remembered "sitting in our new Ford passenger car on the bank of the Virgin River and looking at the sign 'Ring Bell for Team.' The driver honked the horn three or four times, and in a short time, a farmer who was plowing a field on the opposite side appeared with a team, doubletrees, and a chain and for 25¢ pulled us across the wide sandy stream."

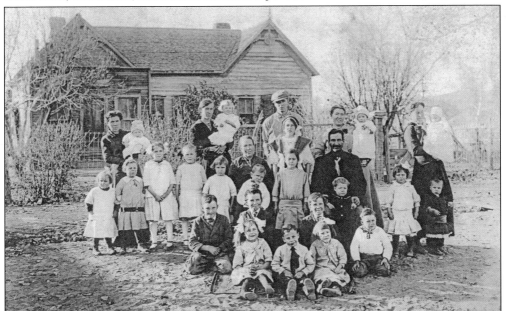

The James Elmer and Sarah Ann Burgess Hughes family poses in front of their lumber home in Mesquite. James's brother Walter built it, and the home features unusually detailed woodwork for pioneer homes in Mesquite. Walter Hughes was involved in most home building and public building projects at that time in Mesquite. The home was located on the southwest corner of Willow Street and First North Street and was next to the Hughes Store.

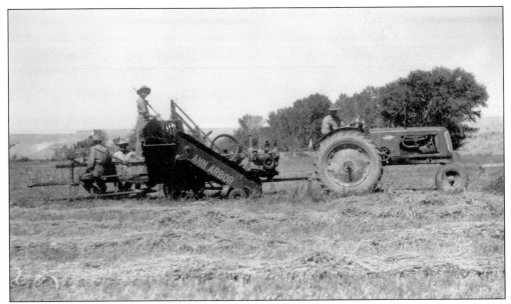

A hay baler was a great labor saver and was welcomed by farmers who could afford such things. Neighboring farmers would come to help at baling time, and the machinery would then go to their fields to bale their hay. Lew Pulsipher is shown driving the tractor, while neighbor Jay Leavitt stands on the baler, and Jim Pulsipher and Jody Leavitt tie wires on the bales. (Courtesy of Jerry Pulsipher.)

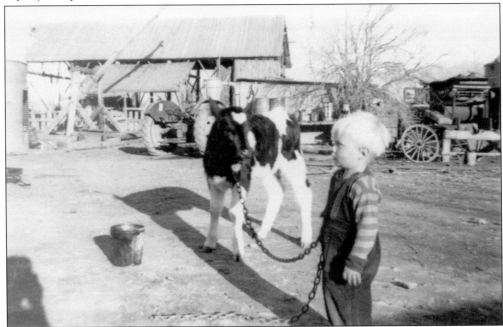

A grandson of Charles Arthur Hughes, Eugene Hughes is at the family dairy with a favorite calf. His father, Marion (Tex) Hughes was one of the sons in the business C. A. Hughes and Sons Dairy. Even the grandsons were expected to do their share of work about the farm, and some continued in the work while others chose to seek careers elsewhere. Eugene taught school in Arizona and Nevada for nearly 32 years. (Courtesy of Connie Hughes.)

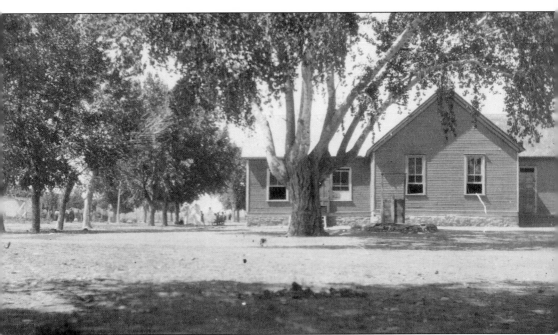

This photograph of the lumber Mesquite School shows the building as it stood on the northeast corner of Mesquite Boulevard and Willow Street. The cistern provided water for the school, and the huge trees helped to cool the playground. In the photograph, children can be seen sitting on benches and playing games. This school was built in 1910 and had four class rooms with two grades to a room. It was also used by the townspeople as a church along with the smaller White Steeple Church across the boulevard. After opening services in this building, the congregation would divide to go to either building. Those that went across the street attended Sunday school classes in the white building, which was divided into separate rooms by curtains.

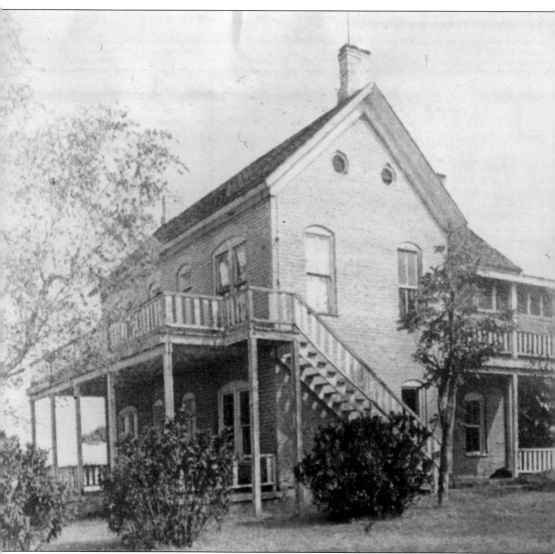

The Thomas Leavitt Home in Bunkerville was one of the few two-story homes in the valley. It had multiple doors to the outside to accommodate the separate living quarters of plural wives. Mormon apostle Wilford Woodruff visited Bunkerville to avoid federal marshals who were attempting to arrest and imprison polygamist men. The Leavitts helped hide him in the top story of the home, which is indicated by the two small round windows.

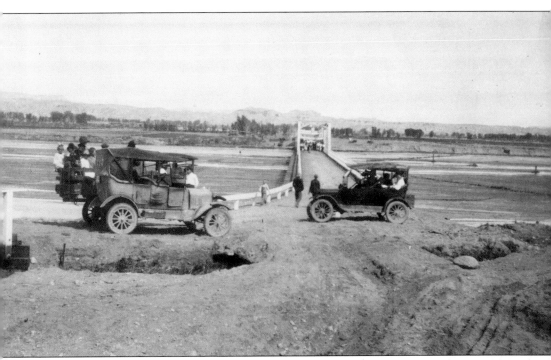

March 18, 1921, was declared Bridge Day with the opening of the first bridge to connect Mesquite and Bunkerville. The Nevada governor attended the ceremony held in the middle of the bridge with about 2,000 other people. The all-day celebration included speeches by dignitaries, music from an orchestra sent from St. George, Utah, prayers by church leaders, a "Golden Spike" driven by the Bridge Day Queen, a barbeque feast, and a dance held right on the bridge, which lasted late into the night. The celebration involved the region because the bridge eased travel across the southern part of the state. After the celebration and as crowds thinned, young people driving back and forth across this new steel spanned wonder, which was draped in bunting and an American flag, made many trips. The construction of the bridge had also brought good wages into town, with workers being paid $5 for a 10-hour day. (Courtesy of Jerry Pulsipher.)

This photograph shows the Bunkerville Rock Church after it burned in 1920. For students wanting to continue their educations after high school, it was devastating because it left the normal school without a building. The decision was made to move classes into private homes, so there was no interruption of schooling for these future teachers. (Courtesy of Dorothy Thurston.)

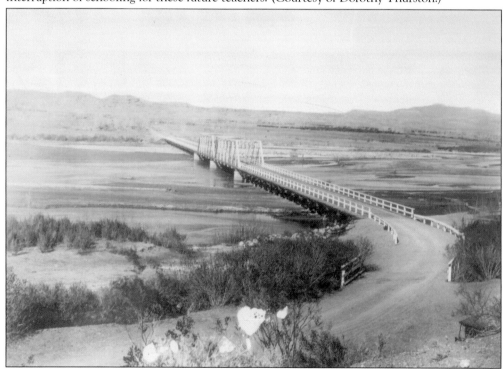

Now a link in the Arrowhead Trail, Mesquite's first bridge continued to be battered by floods, and the treated wooden pilings suffered damage that eventually lead to a replacement being built. Despite the steel spans in the middle, the footings could not withstand the constant erosion of the river.

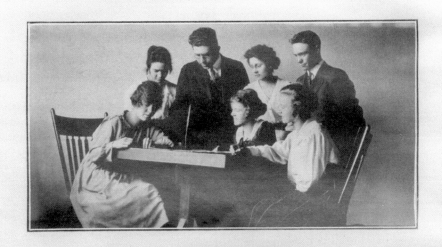

"THE YUCCA" STAFF

ELLA EARL...Editor
ELTHERE LEAVITT......................Assistant Editor
ALICE BARLOW.........................Assistant Editor
RALSTON HUNT.......................Business Manager
LEA LEAVITT Alumni Representative
ANNA W. HAFEN............................Art Editor
WILMA MILES............................Literary Editor
L. R. HAFEN............................General Manager

We, the members of the staff, humbly beg of you to be pleased with this pioneer production of the "Yucca." Remember that we have had an unbeaten path to tread. The midnight oil has burned to light the way for this yearbook. So, kind reader, if the book is not all that you wanted it to be, give us your sympathy rather than your censure.

If, when glancing through its pages, you fail to find your face or name, and fain would criticize, remember this: "Faces unseen are sweetest."

But if you find your face or name—oh, many times—and fain would criticize, remember this: "He who is prominent enough to be talked about must be worth talking about."

We take this opportunity to thank all who have helped to make this project a reality—the students who have so loyally supported us; the Alumni, who, though they have left our halls, have taken our problem as their own, and our advertisers who have responded so generously.

By 1920, Virgin Valley High School had grown and wanted to join other schools in producing a yearbook. This page from the first *Yucca* shows the hard working staff and their plea for readers to be pleased with their pioneer production.

Martha Cragum Cox first taught in the valley in 1890 at the Bunkerville Church Academy as the first Nevada certified teacher to teach there. Though she was a plural wife with a husband trying to avoid federal marshals, leaving her the sole supporter of her children, she donated one month's salary to the building of a new school. In 1900, Martha was teaching school in Mesquite in a 16-by-16-foot tent with a dirt floor and logs for benches. (Courtesy of Dorothy Thurston.)

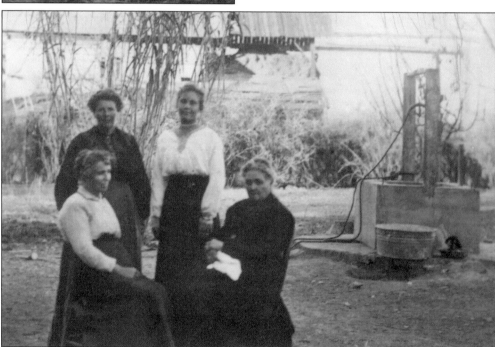

Four generations of Leavitt women are photographed in a yard near a cistern. This method of storing water for use in homes was brought to the valley when a returning missionary shared what he had seen in Nebraska in 1895. These cement-lined underground tanks were filled with water when the river was running cleaner (like during spring snow melt) to be used when the river was muddy.

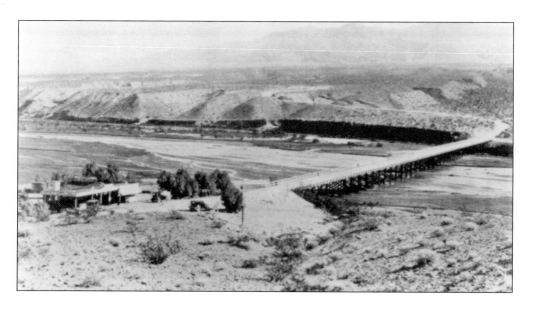

The Riverside Bridge constructed of treated-timber piles is shown in the above photograph and in the lower photograph in February of 1932 when a flood washed it out. Earlier in 1929 when both the Riverside Bridge and the Mesquite Bridge were damaged in a flood, traffic was backed up all along the road. More than 200 travelers were stranded in Mesquite and Bunkerville. After the few tourist cabins were filled, local residents housed and fed people in their own homes. For three days, the townsfolk held dances, picnic dinners, and other activities to help entertain the marooned travelers. Even as the water subsided, horses were needed to pull vehicles through the mud.

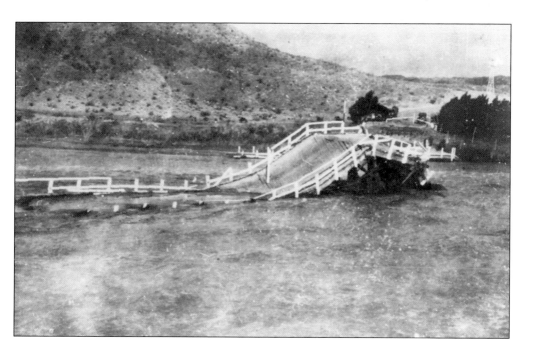

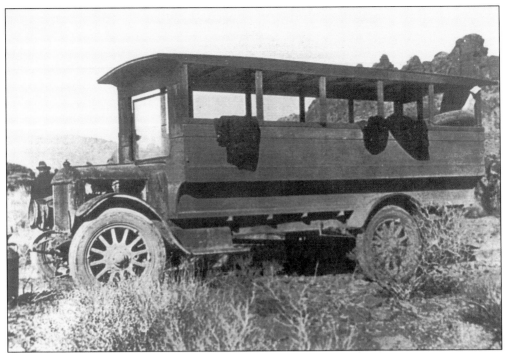

This vehicle, nicknamed "Old Henry," was the first school bus in the valley. Lew Pulsipher and Vie Hancock made the bus from a truck body, and it was used in the early 1920s to take children to school in Bunkerville from Mesquite. Previously, the students would walk or ride horses the five miles to school. The bus drivers were Vie Hancock and music teacher Henry Fordham.

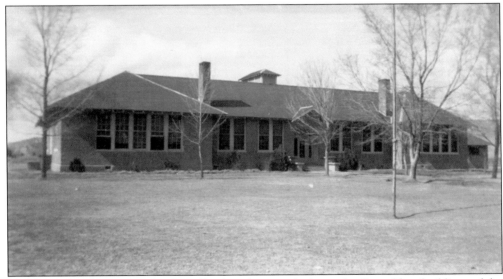

To be completed in 1917 in Bunkerville, this photograph shows the first of four buildings of the Virgin Valley High School. It was equipped with gas lighting and contained a central hall leading to a large assembly/recreational/eating hall, library, classrooms, chemistry lab, and sewing and cooking rooms.

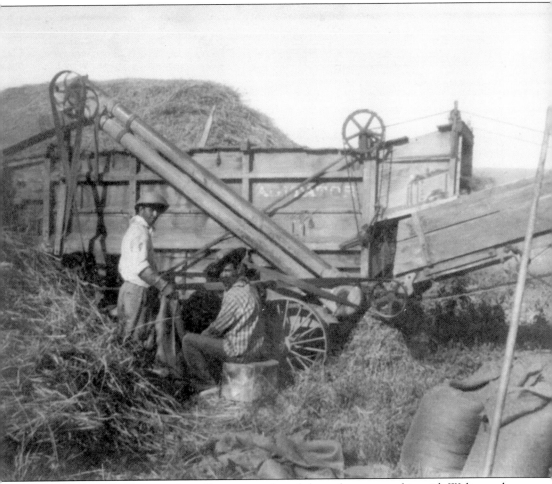

The first threshing machine in the valley was purchased through a partnership with Walter and Arthur Hughes, Charles Hardy, and Jeremy Leavitt in 1912. It was a huge heavy piece of equipment, which required six teams of horses to pull it and 21 men to operate. The team driver used a long whip to keep things moving, and the job was dusty and dirty with chaff blowing everywhere covering the whole crew. For 13 years, this machine harvested crops throughout the valley with the partners keeping each tenth bushel as payment. As the threshers worked in the fields, the women were working equally hard preparing food for them. Meals of lamb, fried chicken, ham, potatoes, fresh bread, fruit salad, corn, squash, pies, and cakes were prepared to be served at long tables in the shade. Children were kept busy running errands and fanning away flies.

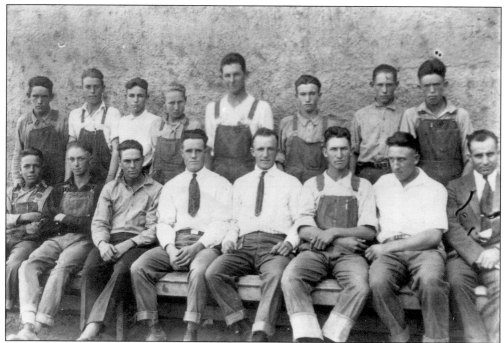

Mr. Darley's 1923 high school agricultural class includes, from left to right, the following: (first row) Anthony Abbott, Robert Waymire, Andrew Pulsipher, Elmer Graff, unidentified, Melvin Leavitt, Merle Wittwer, Mr. Darley; (second row) Glenn Waite, Austin Hunt, Kendall Bunker, Stan Neagle, Laurel, Erwin, Randy Leavitt, and Morly Sprague. (Courtesy of Claudia Leavitt.)

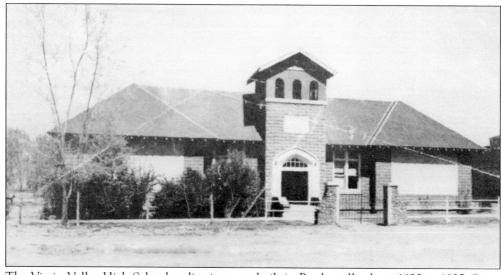

The Virgin Valley High School auditorium was built in Bunkerville about 1923 to 1925. Since it was the only high school in the valley, some Mesquite parents moved their entire families to rented or borrowed homes near the school or placed their student children to live with Bunkerville families for the school year with only weekend trips home across the river. (Courtesy of Claudia Leavitt.)

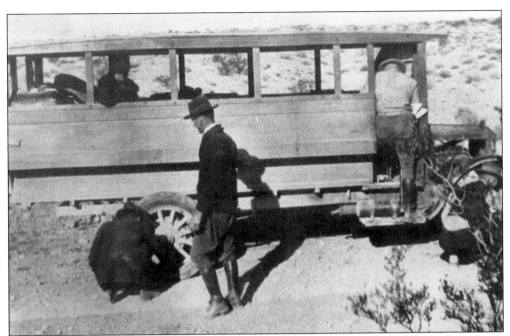

This photograph shows Henry Fordham and other teachers stopped in the Valley of Fire repairing a tire while on their way to a teachers institute in Las Vegas. This open-air school bus was at times so slow and cold in the winter that Leonard Reber remembered riding to school one time when Orange Barnum got out and ran along beside it to keep warm.

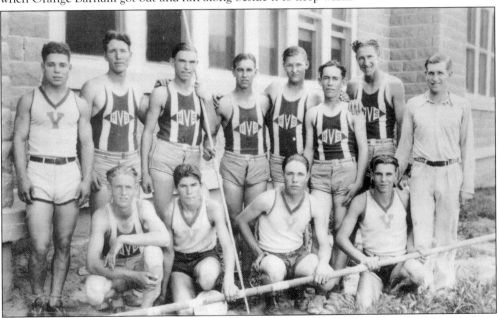

The 1931 Virgin Valley Track team includes, from left to right, the following: (first row) La Von Jensen, Hafen Leavitt, Steve Abbott, Marian Hughes; (second row) Cyril Granger, Iran Tobler, Kay Bunker, Fenton Frehner, Newell Knight, Denzil Waite, Clair Neagle, and coach Reed Blake. Athletics came naturally for some of these boys who came from hardworking farming families where strength and endurance were required. (Courtesy of Claudia Leavitt.)

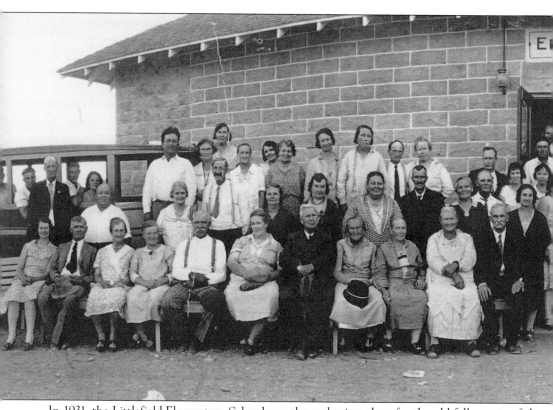

In 1931, the Littlefield Elementary School was the gathering place for the old folks party of the Virgin Valley. School buses were used to transport the attendees from Mesquite and Bunkerville. Many were original settlers to the valley, but by this time, most of the oldest first settlers were

gone, and those shown are those that came as children. The Littlefield schoolhouse was built in 1924 and had one class of all ages of children. These reunions and gatherings still continue each year in Bunkerville. (Courtesy of Dorothy Thurston.)

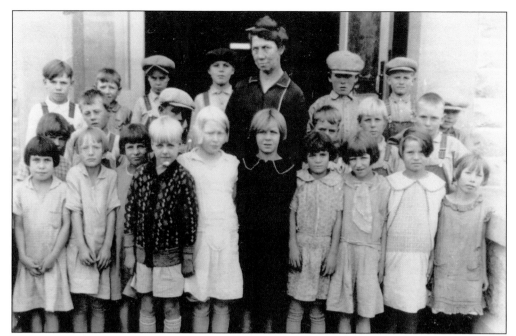

The upper grades of the Mesquite Elementary School are shown in 1930 with teacher and principal Emma Abbott, who was a favorite of many students. When a competition was held at the opening of the first bridge between Mesquite and Bunkerville, Emma was voted the most popular woman in the valley and chosen to drive the "Golden Spike" to open the bridge to travel.

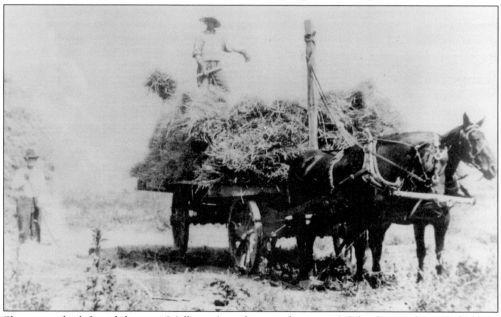

Shown on the left with his son, Melburn (standing on the wagon), John Jensen farmed alfalfa in Mesquite. With the favorable climate in the valley, alfalfa can be harvested seven to nine times in the season making it a profitable crop for this area. It was the favored feed for cows and horses and was in increasing demand as people acquired more animals. In the early days of settlement, alfalfa greens could also be found on family tables.

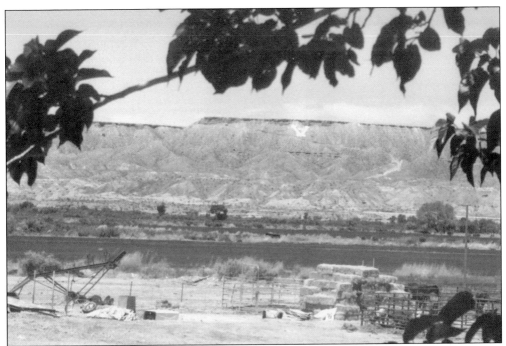

The Virgin Valley High School class of 1929 took the project of constructing a large block "V" on the side of the Mormon Mesa, which could be seen from their school. The outline was filled with rocks and then painted with white wash. With the 1st of each April, the tradition continued with the school allowing students to hike to the location, repair any damage done by weather, and refresh the whitewash.

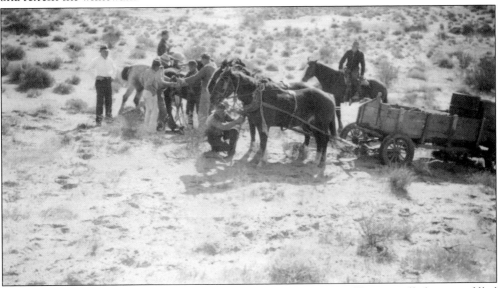

This 1937 photograph shows the work involved in "V Day." Teams of horses pulled wagons filled with water barrels to the site where the lime was mixed for whitewash paint. It was later decided to not allow the female students to assist, and they remained on campus to wash windows and clean the school grounds. Much later liability issues with the school district discontinued the event as a school sanctioned activity, but it has continued as a private project.

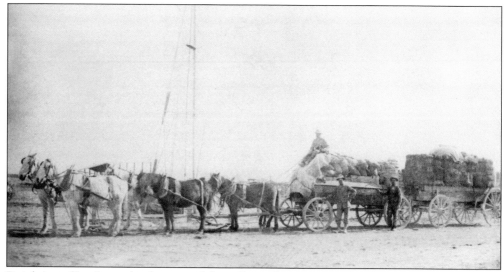

Freighting offered ways for the men of the valley to bring in much needed money. Freighting to mining camps and railroad projects, hauling freight from train station to town stores, bringing ore from mines to processors, and taking loads of valley grown fruit and meat to Las Vegas or northern towns were all jobs for local freighters. John Jensen is shown with his loaded outfit in 1900. (Courtesy of Dorothy Thurston.)

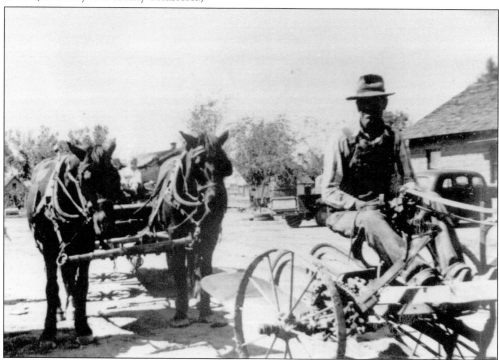

Charles Arthur Hughes and his family moved to the valley in 1896, and as did many men of the valley, he later had to leave to find work. He drove a stagecoach from Las Vegas to Goldfield, Nevada, for 18 months to be able to purchase land in Mesquite, which was the beginning of C. A. Hughes and Sons Dairy. The dairy grew to become the largest in Mesquite where the family milked about 650 cows twice a day. (Courtesy of Dorothy Thurston.)

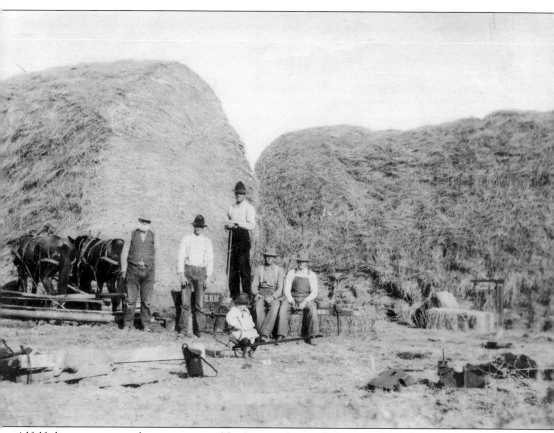

Alfalfa hay was a crop that growers could rely on to be needed everywhere there were cows and horses. John David Pulsipher is shown on the left in this 1915 photograph with his "hay crew" at the family's haystacks west of Mesquite. His crew usually consisted of his sons Lew, Howard, Stan, and Earnest. (Courtesy of Jerry Pulsipher.)

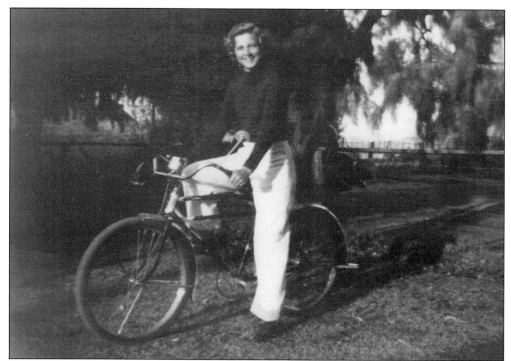

Hazel Pulsipher is seen in this photograph on her bicycle in the early 1930s. It was her favored mode of transportation from her family's farm on the far western edge of Mesquite. Her father owned the local telephone company and the switchboard. One of the few telephones in town was in their home. When calls or telegrams for residents arrived, it was Hazel's job to run or bicycle to the appropriate homes with the message. For this, 10¢ was paid to Hazel. (Courtesy of Hazel White.)

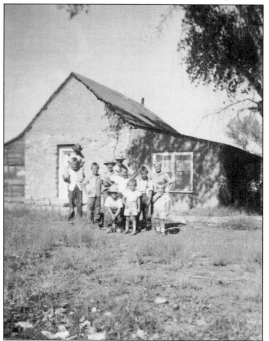

This rock house was built during the first attempt to settle Mesquite in 1880. It was made from rock gathered from a nearby hill and was stacked on top of each other with mud mortar. In places, the walls are 20 inches thick, creating an effective insulating barrier, especially, against summer heat. It originally had only one room, but through the years, enlargements have been made to include a bedroom, kitchen, and bathroom. It still stands at the southeast corner of Willow and First North Streets.

Three

PROGRESS

Floods were still frequent, requiring the dams to be rebuilt up to 15 times a year. For trips between Mesquite and Bunkerville, the river had to be crossed where quicksand and hidden holes were no small obstacles. Horses usually rested on the banks before being driven hard to reach the other side. It would take until the 1950s for a permanent dam to be built on the Virgin River. Public works projects often involved the dedicated help from the public, as when a road six-rods wide and one-and-a-half-miles long was completed down the center of Mesquite. For three years, the town devoted the last Saturday of each month to road building, bringing their own implements and teams. On these days, the women did the cooking and baking for the community meal. The bond created by these common goals resulted in a civic responsibility that carried through to other endeavors, benefiting the whole community.

In 1916, the People's Progressive Telephone Company was organized in the region to furnish telephone lines from St. George, Utah, through Littlefield and Mesquite then on to Moapa Valley and the railroad station at Moapa. The railroad station had the Western Union telegraph line; thus, communication with the world was available.

Water from Cabin Springs was piped down closer to the towns in 1938 and was collected in tanks, where individual families could take what they needed. In 1945, Mesquite residents furnished the labor to construct a home delivery system for culinary water to each property, and in 1949, the first culinary well was drilled and supplemented the spring water for Mesquite.

The rest of the country was ahead of the valley in modern improvements, but finally, with the completion of Hoover Dam, a $120,000 loan from the Rural Electric Administration, and the formation of the Overton Power District No. 5, electricity arrived in the valley May 13, 1939.

Continual improvements that were done on the roads during the 1930s helped make travel a little easier and brought some of the modern world in.

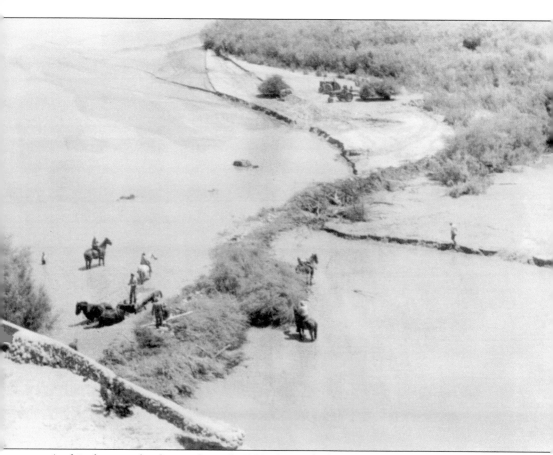

As this photograph taken in the early 1950s shows, the brush dams on the Virgin River demanded nearly constant attention. Later that decade, government loans were obtained, and the United States Soil Conservation Service engineers moved the dams to more rocky areas, fortified them with concrete spillways, used railroad rails as pilings, and finally established the first permanent dams in the valley.

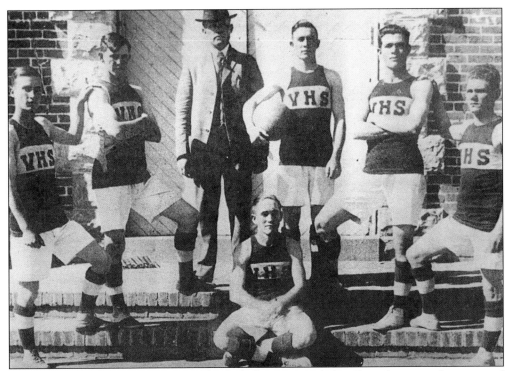

The 1916 Virgin Valley High School basketball team traveled to Reno by covered wagon and train to defeat all opponents and become state champions. Team members are, from left to right, (standing) Eldon Wittwer, Ralph Huntsman, Coach Erastus Snow Romney, Albert Leavitt, Laman Leavitt, and Milton Earl. Nobel Waite is seated in front. (Courtesy of Claudia Leavitt.)

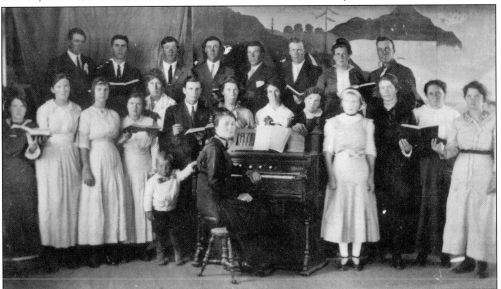

In the front row behind the child, George H. Bowler was leader of this church choir and came to the valley as a schoolteacher. He was an accomplished musician and played the violin. His wife, Nancy, played the mandolin and piano, and their oldest daughter, Bessie, played the organ. Together they formed a family band and played at many valley dances and programs.

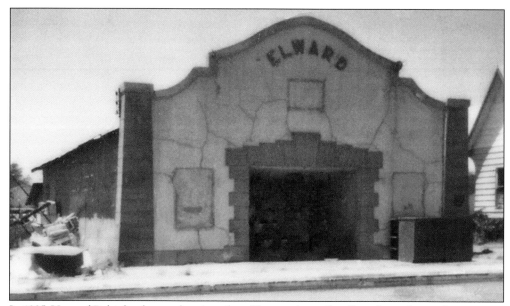

In 1925, Howard Pulsipher began showing silent films on the walls of his white-plastered auto-repair garage. Later he and Elmer Hughes joined forces and their names to open the Elward Theater in 1934 and ran movies on Friday and Saturday nights. Mike Burns bought the business in 1939 and continued it until television came into the valley in the 1950s.

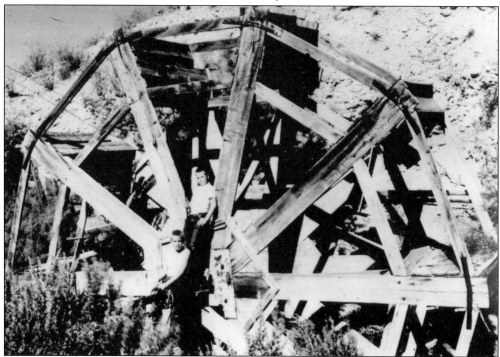

Waterwheels were sometimes used on the irrigation canal to divert water to a crop that was a little higher than the canal. The wheel scooped, lifted, and poured the water into a ditch to the field. This waterwheel in Mesquite was used to water alfalfa fields planted and grown by the Hughes brothers near their dairy.

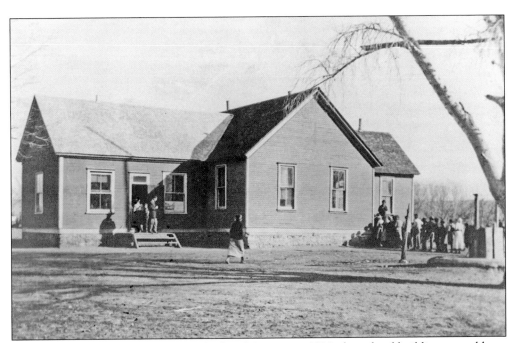

After the new elementary school was built in Mesquite in 1923, this school building was sold to a private owner and used for other purposes. The town's first doctor, Dr. L. L. Gilbert at one time used the building as an office and living quarters. After the building was completely abandoned, the lumber was used for other construction, and the lot later became the site for Don Lee's service station.

This photograph shows the Virgin Valley High School band about 1917. Shown wearing their hats band members are, from left to right, (fist row) Milton Earl, Roy Waite, A. L. Kelly; (second row) Myron Leavitt, Willard Leavitt, Eldon Leavitt, Albert Leavitt, and Warren Leavitt. Band member A. L. Kelly was the principal and soon to become school superintendent of the newly formed Educational District No. 1. (Courtesy of Dorothy Thurston.)

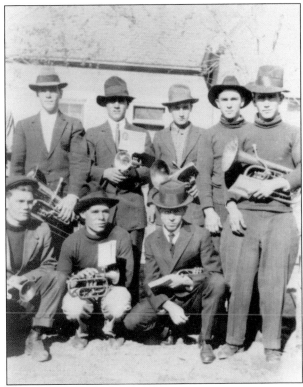

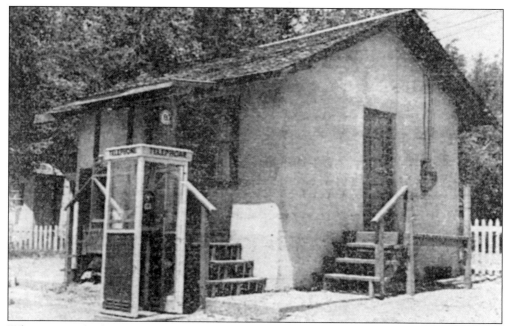

When Lew Pulsipher furnished 40 miles of wire for the phone lines in 1916 and the People's Progressive Telephone Company was not able to pay him, he reluctantly accepted company stock, which made him the largest stockholder. He later bought out the other shareholders and renamed it the Rio Virgin Telephone Company, which occupied the small building in the photograph above. That company is now named Reliance Connects.

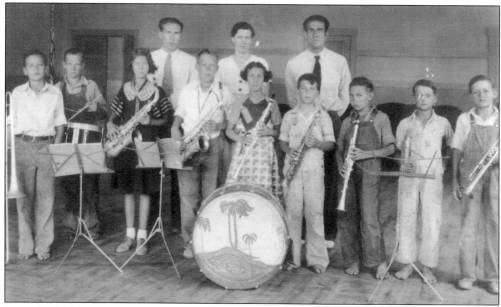

Music in the local schools was an important element of the students' education, as shown in this 1935 photograph of Mesquite Elementary School band. In 1924, the high school had 27 students who played the violin, 14 who played the cornet, 3 who played the trombone, and 2 who played the saxophone. It also had a 50-member mixed chorus. As with most other things, if the valley residents wanted music, they had to make their own. (Courtesy of Dorothy Thurston.)

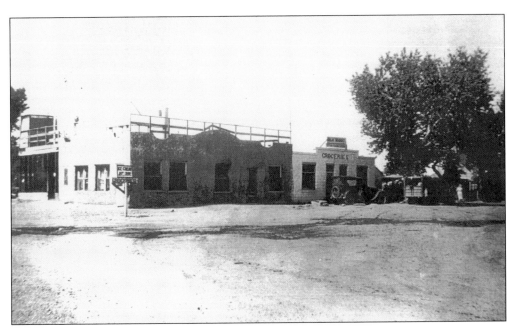

On the southwest corner of Sandhill and First North Streets, Alf Hardy had a building, which was used for a variety of things through the years. In the photograph above, the building can be seen being used as a store and an apartment. The roof or upper floor appears to be in the process of becoming the dance hall that it eventually became. Adjoining that building to the west is the store, which has been photographed from the inside, shown below. The proprietor, John (Shorty) Eno, shown on the left, stands with customer Jenny Hughes Barnum. Note the "strictly cash" sign.

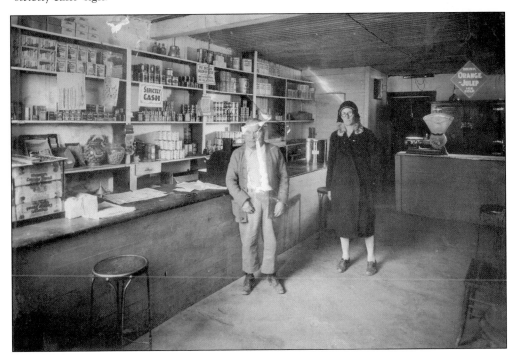

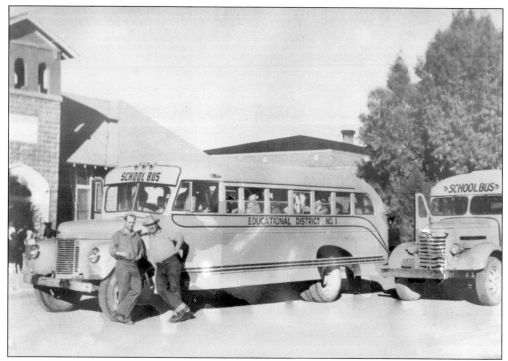

Starting in 1940, newer and bigger school buses were needed when all high school students went to Bunkerville and all elementary students to Mesquite. There was a one-room grade school in Littlefield, Arizona, that the children walked to, but the "out of state" high school students had to be brought to Bunkerville by their parents. Mojave County School District in Arizona paid the Nevada school to educate those students.

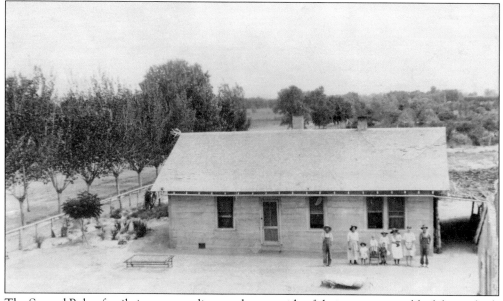

The Samuel Reber family is seen standing on the west side of their new cement-block house built in 1919 on Mesquite Boulevard near Grapevine Road. This photograph taken from a neighbor's roof shows the many trees throughout Mesquite that lined streets.

Howard Pulsipher's home was next to his auto repair garage, and this photograph also shows a small house on the right that he moved onto his property for his mother-in-law, Clara Granger, when she was widowed. That small building on the right had once been the tithing building for the town, which was where church members brought mostly in-kind tithes, such as chickens, eggs, grains, and produce. Pulsipher's residence was the first in the valley to have plumbing throughout the entire house.

In 1935, the grade school children were brought from Bunkerville to attend school in Mesquite. The Mesquite Elementary staff are, from left to right, (first row) Earlin Tobler, Merle Jones, Zella Pulsipher, Leonard Reber; (second row) Oscar Abbott, W. L. Martin, Ralph Huntsman, Jake Leavitt, and Ace Barnum. (Courtesy of Dorothy Thurston.)

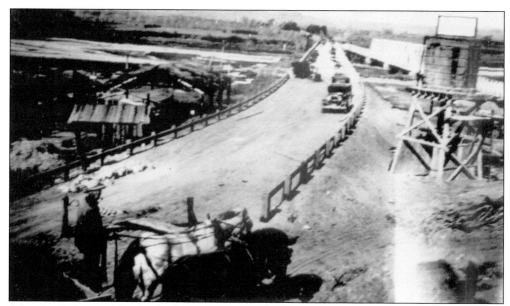

After floods damaged the first bridge, a new cement bridge was built just to the west of the old bridge, which was later torn down. This 1932 photograph shows the construction of the wider lower bridge that had a total cost of $125,000. At the time, it was the longest spanned bridge in Nevada.

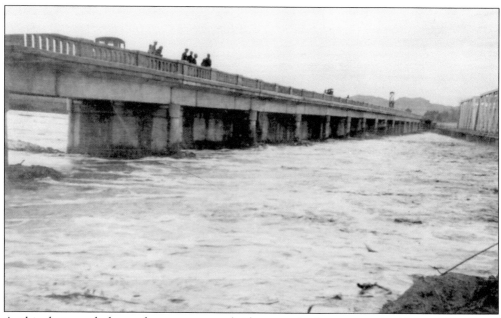

As this photograph shows, the new concrete bridge proved to be strong as it withstood floods and increased traffic. During World War II, lengthy military convoys traveled cross-country passing through Mesquite by way of the river bridge. Local men armed with rifles took shifts guarding the bridge against sabotage and occasionally enforcing mandated "blackouts," which was when drivers were required to turn off auto headlights.

The Virgin Valley High School graduating class of 1918 included, from left to right, the following: Kathleen Cox, Charity Leavitt, Kenneth Earl, Ralph Huntsman, Lara Bowman, and Ethel Hardy. The classes grew through the years but remained small. In 1931, the number reached 21, the largest to that date. The 1965 graduating class had 22 students. (Courtesy of Dorothy Thurston.)

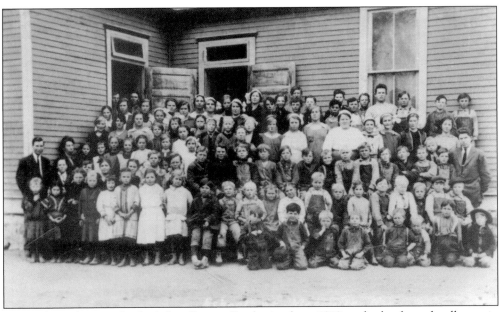

Pictured standing on the far left is George Bowler in about 1919 at the lumber schoolhouse in Mesquite. Bowler taught school in Mesquite from 1910 to 1920, which was when he was made principal. He also farmed, helped build and operate the flourmill, was postmaster, performed duties of the president and secretary of the Mesquite Farmstead Water Board, ran the Wagon Wheel Motel, operated a calf nursery, and was chairman of the first Juvenile Delinquent Committee in Mesquite.

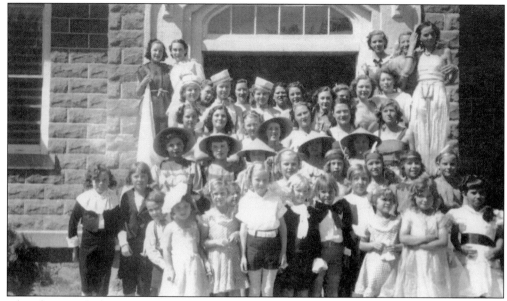

This photograph shows Miss Pete's 1938 dance review that was regarded as being "the outstanding feature of the Virgin Valley Schools Physical Education Department." It was the first review of its type in the history of the school and provided dance and music by the youth of the valley with 85 students participating.

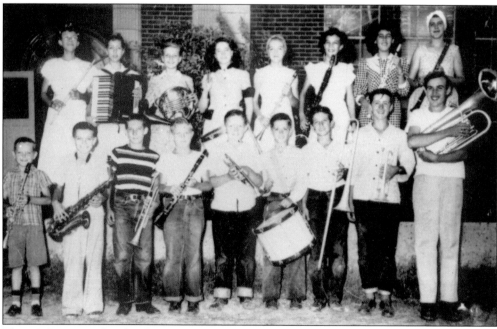

This 1947 summer band indicates that musical education continued in the valley through the summer and was taught to students at the gym in Mesquite. The instruments were borrowed from the school, and the teacher came from Logandale, Nevada, once a week to conduct this class of budding musicians.

School activity offers a diversified field large enough to hold the interest of many whose fancies differ. Those who incline toward the fine art of "Acting" have had splendid opportunity to develop stage presence, poise, and voice as the three plays presented this year have given experience to large group of students.

"Just Another Day" presented at Christmas time, was a rather heavy drama but very well given.

A western comedy pleased everyone for the school play. "Moon River Rancho" offered character roles that will always be remembered. Its comedy of action and dialogue will never die.

SCHOOL PLAY

The Seniors were presented in a comedy-drama of mystery, "Drums In My Heart." Grace Pulsipher gave us a never to be forgotten interpretation in the role of the grandmother. She had excellent support from other members of the cast who performed equally well. The Seniors are contributing toward the purchase of a new cyclorama.

The plays this year have been directed by Alton H. Peterson, our art teacher. He says that although our school is small, we have a lot of talent worth training.

The 1937–1938 edition of the Virgin Valley High School yearbook, the *Yucca*, shows the effects of the Depression. To economize, the yearbook was hand assembled and the photographs were glued to each page. Also to save, there were no individual student photographs, but group shots were used. Despite the hard economic times, it appears activities continued in the drama department, with plays and theatrical productions that were very popular.

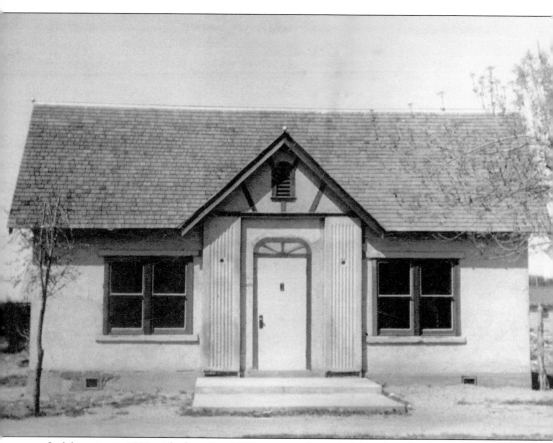

In Mesquite in 1928 with the other LDS meetings being held in the school, women of the Relief Society felt they needed their own building. They held fund-raising bazaars and even grew crops of cotton without the assistance of the men, from planting, harvesting, and hauling the crops to the mill in Washington, Utah, which was more than a three-day trip. With the money they raised, they had a building constructed but outgrew that in a few years and set about to enlarge and remodel it to include a baptismal font, because at this time, baptisms were being preformed in the large irrigation canal year round. Even before remodeling was finished, baptisms were being performed in the cement font, which was sunken in the floor of the new building. The photograph above is the building as it was completed in 1943, using volunteer labor, leftover paint, a donated door, and homemade curtains. In 1952, the women were asked to sell the building to help buy the property for a new Mesquite Chapel with the promise of a room dedicated for their use. (Courtesy of Hazel White.)

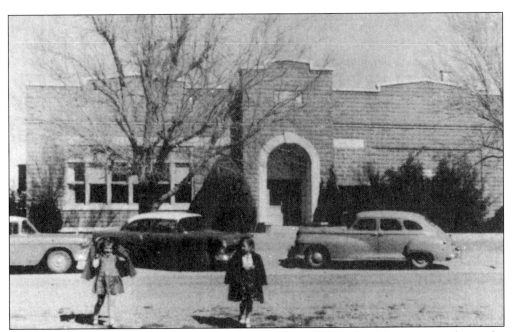

The Mesquite Elementary School auditorium was built in 1923 on the old town square lot on the northwest corner of Willow and First North Streets. It was decided in 1935 that all elementary children in Mesquite and Bunkerville would attend this school. (Author's collection.)

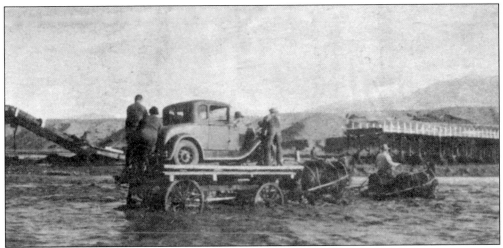

As the owners cling to the back of their car, they are carried across a still flooded Virgin River atop a farm wagon pulled by horses. Young local men found this to be a lucrative business when travelers were not willing to wait several days for floodwater to recede to passable levels. The washed out Riverside Bridge can be seen in the background, probably in 1932.

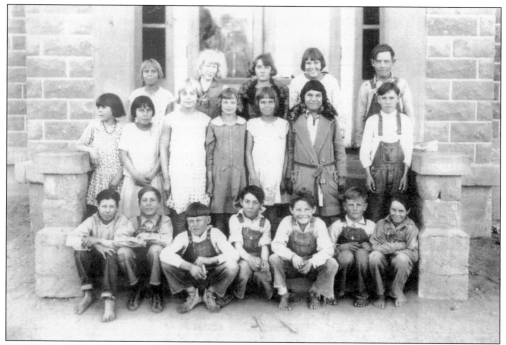

In 1930, the fifth and sixth grades of the Mesquite Elementary pose at the east entrance of their school. The next year required the sixth graders to be bused over the river to the Virgin Valley High School in Bunkerville. For some, it seemed a great distance and a frightening experience. Note the many bare feet that show the valley was still enduring hard times. (Courtesy of Dorothy Thurston.)

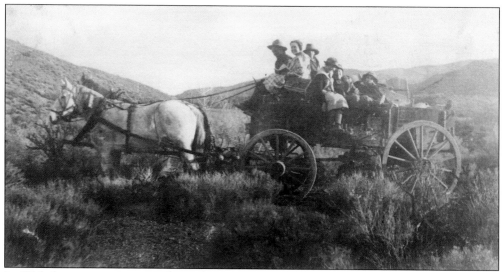

In 1916, the opportunity came for students to earn college credit by attending a normal school (teacher-preparation school) in Bunkerville. When the 1918 flu epidemic hit the valley, schools were closed, but the students (all girls) of the normal school were taken to the nearby mountains to be quarantined from the town below. The photograph above shows Dudley Hardy driving the loaded wagon to the new "campus." (Courtesy of Dorothy Thurston.)

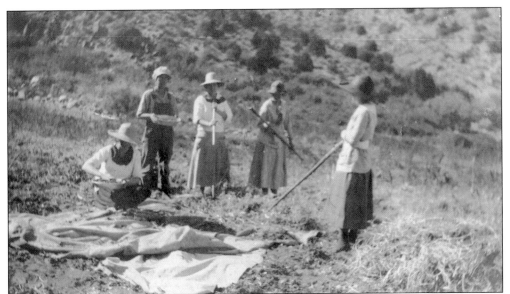

The teacher of the normal school was young Columbia University graduate Mina Connell, who guaranteed each graduate of her school a job. Her six students were Charity Leavitt, Juanita Leavitt, Leah Leavitt, Ethel Hardy, Mary Woodbury, and Retta Leavitt. Here they are shown setting up the tent that they would use for sleeping and nighttime studying. They prepared their own meals over a fire and supplemented their meat supply with small game shot by one of their own. (Courtesy of Dorothy Thurston.)

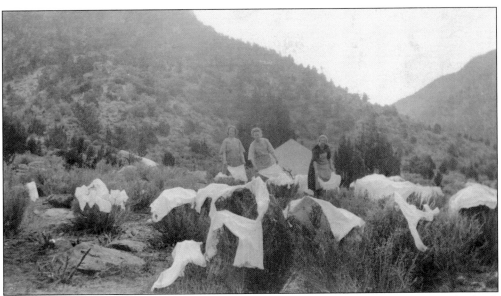

Once a week, supplies from home would arrive at the mountain campus of the normal school. Although they were homesick, Connell inspired her students to learn and stay focused on their goals to become teachers. In the above photograph, the girls are spreading their washing on the bushes to dry. There was no interruption in their schooling, so by the start of the next school year, these young women were teachers. (Courtesy of Dorothy Thurston.)

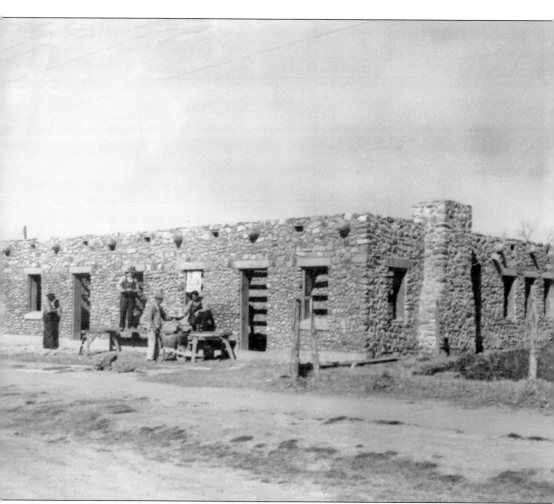

The National Youth Administration was a government-funded program that brought badly needed money into communities all over the country by employing young people in public works projects. In 1941, Mesquite applied for and was approved to build a library as a branch of the Clark County Library District. The lot cost $150, and Walter Hughes directed the project, which included gathering rocks from across the river, hauling gravel, and bringing logs from the Hancock Peak Sawmill. The young men then stacked the rocks using cement for mortar. The building had a pueblo-style flat roof, a fireplace, and cement floors. The next year the town received permission to use the building as a hospital, and a nurse from New York agreed to move to Mesquite. Living quarters were provided in the building for Bertha Howe and her husband, Charlie, living there until 1977.

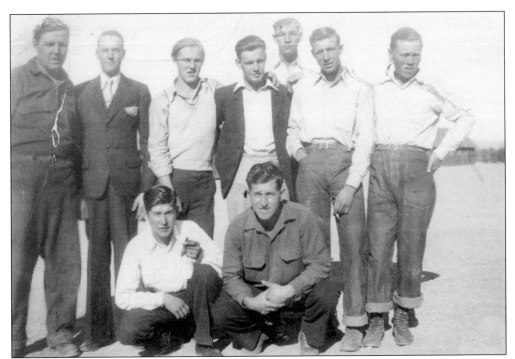

In this 1933 photograph are young men from Ohio who came to the valley with the United States Civilian Conservation Corps (C.C.C.), which was President Roosevelt's program that provided jobs for Americans during the depression. From their camp in Bunkerville, they helped lay pipe from mountain springs for better drinking water and built flood checks in the washes south of the valley, which are still in place.

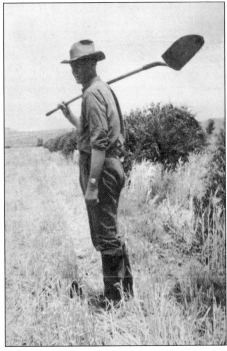

In 1937, Lew Pulsipher was a foreman of a C.C.C. crew and the president of the Mesquite Irrigation Company. The C.C.C. camps were breaking up and moving to other areas of the country when a devastating flood destroyed the irrigation systems in the valley. Through associations, Lew was able to explain the great need for help and got authorities to visit. Within 24 hours, equipment and manpower arrived to restore the irrigation system. (Courtesy of Jerry Pulsipher.)

This photograph shows the Mesquite School gymnasium that was built in 1939. Besides a large basketball court, it held the kindergarten and first- and second-grade classrooms. Starting in 1942, hot lunches cooked on a wood-burning stove were served to students in this building, which also served as a public hall for town functions, such as dances and celebrations, and was rented for church use. (Author's collection.)

When water from the springs in the mountain was not enough to carry the growing population through the dry season, help was sought through state assemblyman William Embry, shown above on the right inspecting the new five horsepower deep well pump that had just been installed at the newly drilled well. The existing pipelines and nearby power lines made this site, just over the river from Mesquite, the best possible location. (Courtesy of Hazel White.)

A large steel tank was donated by the Clark County Commissioners and moved with county equipment from Las Vegas to the site of this first well. It was a wonderful surprise when the water was not only sweet and clear but also very soft and free from "elements of an undesirable nature." Pictured are, from left to right, Faye Leavitt, Don White, Sen. Val Pitman, and Deloy Abbott. (Courtesy of Hazel White.)

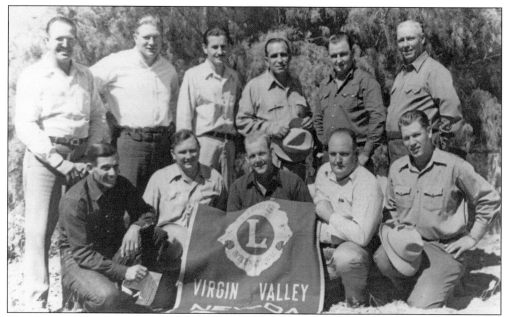

The Virgin Valley Lions Club had the responsibility for the Clark County Fair. The Chairmen in 1949 are, from left to right, the following: (first row) Fielding Hardy, Don White, James Pulsipher, Sylvan Hughes, Phillip Abbott; (second row) Elmer Hughes, Howard Christensen, J. L. Bowler, Faye Leavitt, Orlin Frehner, and John Leavitt. They also had fund-raisers through the year to help make civic improvements in the valley.

One feature of the Clark County Fair was the parade held on the main street of Mesquite. In the 1950s, the C. A. Hughes and Sons Dairy entered a float in the parade showing products that their milk was made into by Clark Dairy in Las Vegas. Hughes's grandchildren on the float are, from the left to right, Judy, Dixie, Kathryn, twins Mary Lynn and Mary Lee, Len, Gwen, Twila, Irmaleda, and Sandra Hughes. (Courtesy of Connie Hughes.)

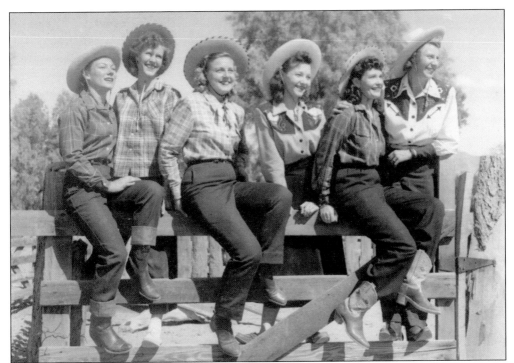

The Clark County Fair Rodeo was a big event held at the rodeo grounds in Mesquite. In 1949, the Rodeo Queen contestants are, from left to right, Rodeo Queen Rose Huntsman and attendants La Vern Adams, Hazel White, Lafaye Leavitt, Rita Pulsipher, and Carmelia Hughes. Some of the contestants were relieved to know they did not have to ride horses. (Courtesy of Hazel White.)

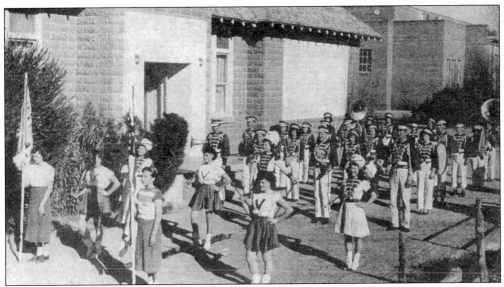

In 1950, the Virgin Valley High School band is pictured in front of the auditorium preparing to lead the Clark County Fair Parade. Marching bands were a big part of the Grand Parade that traveled the main street in Mesquite. Floats were entered from local and county businesses and organizations. (Courtesy of Dorothy Thurston.)

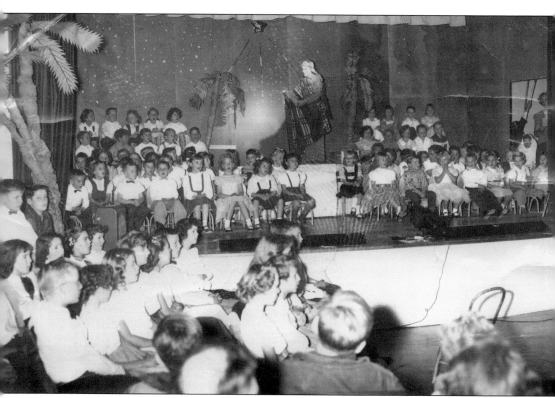

The 1953 Mesquite Elementary Christmas program has been photographed in the school's auditorium. It is obvious that the program has a religious theme. Church would be held the next Sunday at the same location as the Christmas program. Sunday school classes were held in the same classrooms students were taught on school days. The school principal was sometimes also the bishop, so scheduling conflicts rarely occurred. The same arrangement was held in Bunkerville at the high school buildings. (Courtesy of Hazel White.)

This fire station was constructed in Mesquite by the Virgin Valley Lions Club in 1950. The fire truck was a 1942 World War II military-surplus "crash truck" and was very welcomed but not very reliable. Usually, the volunteer fire fighters used their private cars to reach the fire first and did what they could before the fire engine arrived.

J. L. Bowler came to Mesquite with the hopes to build a larger store than he had in Santa Clara, Utah. In 1946, he opened this department store where he sold groceries, clothing, appliances, and hardware. The business was successful, and the building was remodeled and enlarged through the years. More recently, under different owners, the building is used as a furniture store.

In downtown Mesquite in the1960s, open ditches still ran next to sidewalks, and homes still sat beside businesses. The population had changed little from years past but had increased somewhat with families of construction workers from the huge interstate project through the Virgin River Gorge on the far eastern edge of the valley. (Courtesy of Jerry Pulsipher.)

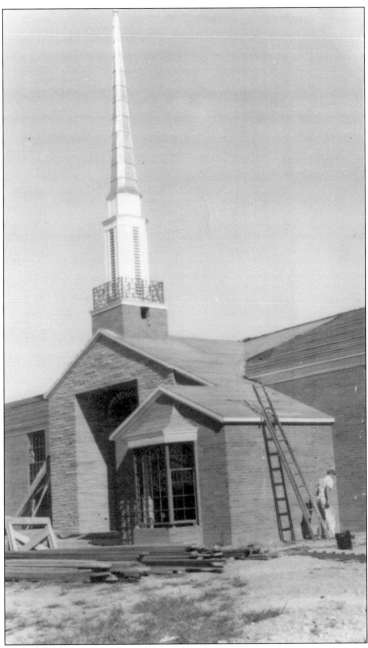

In the 1950s, the LDS Church required the local members to contribute to the cost of their new buildings, so when Mesquite and Bunkerville began their plans for new chapels, they launched fund-raisers among their congregation. On March 4, 1950, the Mesquite members began making cement building blocks, and by May, more than 40,000 blocks had been produced and were ready for construction. Thousands of hours of labor were donated by men, women, and children in the anticipation of a beautiful new building that was constructed on a large lot on Mesquite Boulevard west of Town Wash. Ground breaking was in April 1951, and the dedication was held on March 31, 1953. The building was remodeled and enlarged to accommodate growth until it was replaced in 2000.

This view looking south from the upper level of the Western Village Motel shows how little the valley had changed by the early 1960s. Agriculture was still the dominant feature, and Highway 91, which runs through the photograph, was still not a very busy road. The small lane that leads toward the trees is now named Pulsipher Lane after the family that lived in the house visible in the center. It would be years before the interstate highway system was built to the rear of the Western Village and completely bypassed Mesquite. At that time, there was great concern about how the town could survive when travelers no longer drove through the town center. It was feared that no one would leave the freeway to seek services, and all the hard work of business people would be for nothing. But cross-country travel has increased beyond all expectations, and the popularity of Mesquite as a destination has been established. (Courtesy of Jerry Pulsipher.)

Four

THE TRAVELER

The valley was always a place to travel through on the way to somewhere else. The Old Spanish Trail, the Arrowhead Trail, Highway 91, and later Interstate 15 insured there were always travelers passing through. As the popularity of the automobile grew and improvements to roads and highways were made, America began to travel and explore their country. The Virgin Valley was on the path of some of that movement and found that travelers needed tire or automobile repairs, water for steaming radiators, gas, beds, and food. When Highway 91 was rerouted to the north side of the river and bypassed Bunkerville, Mesquite became the half-way point between Los Angeles and Salt Lake City and was a good place to break up a trip. Businesses that offered the traveler a quick stop or even an overnight stay could be successful. As the tourist business developed, summers were the heaviest traveled months. Schools were out, and families stopped on their way to National Parks or California beaches. Winters were slow, which made it hard for the businesses to survive. However, this worked well for local students who found employment during the tourist season, serving travelers to earn money. Farm work was no longer the only way to get ahead.

Road improvements continued, and the growth and popularity of Las Vegas increased travel and the number of businesses in Mesquite. Basic tourist cabins and cafés evolved into hotels, casinos, spas, and gourmet restaurants. Sand hills and alfalfa fields became golf courses and gated communities. Rutted streets and narrow lanes became boulevards and tree-lined avenues. The once quiet little town is now a force to be reckoned with.

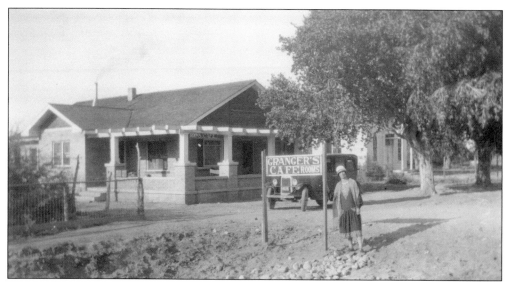

In 1929, the Granger family started serving travelers on the Arrowhead Trail, which went through Mesquite right in front of their business. They had a café and rented out rooms for overnight stays. In this photograph, through the trees on the right, can be seen the White Steeple Church. Clara Granger's daughter, Myrtle Stewart Pulsipher stands by the sign.

William E. Abbott built this house with 13,000 feet of lumber. The lumber was hauled down the mountains east of Mesquite from the Black Rock Mountain Sawmill, which was where Abbott had a contract to deliver logs. He hauled rocks for the foundation and traded a horse for windows and a door. The school district rented rooms for school, and the family rented out rooms as a hotel. In 1926, they added a café to the Abbott Hotel.

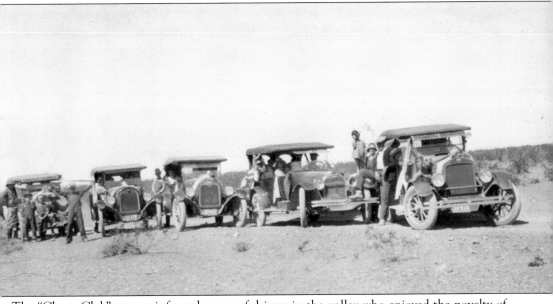

The "Chevy Club" was an informal group of drivers in the valley who enjoyed the novelty of driving their newly acquired automobiles on the roads that were being built. One did not have to own a Chevrolet to join, but that make was in the majority. Shown in the above photograph is the club in 1926 during a run between Mesquite and Beaver Dam. (Courtesy of Jerry Pulsipher.)

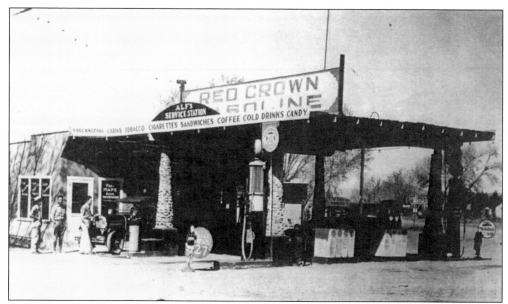

This photograph of Alf Hardy's service station shows the variety of goods offered to travelers. After long hot drives across the desert to reach Mesquite, the most welcomed purchase would probably be a cold drink. Sometimes the "cold" was achieved by simply keeping the bottled refreshment in a tub of water.

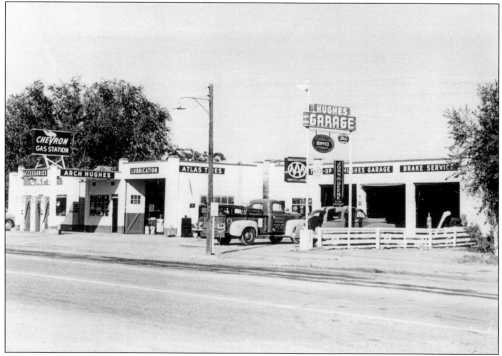

Archie Hughes's station in the 1950s is shown in this photograph. It evolved into a multiservice business. At the far left are the Travelers Café then his Chevron Service Station and Hughes Garage, which his uncle Sylvan Hughes owned and operated. Archie's son Jimmie was Mesquite's first elected mayor in 1984.

When the White Steeple Church was torn down and the wood used elsewhere, the Granger family bought the property next to their hotel and constructed the Granger Auto Court and a service station on the southeast corner of Mesquite Boulevard and Willow Street. This auto court was later renamed the Wagon Wheel Motel and was sold to Deloy Abbott.

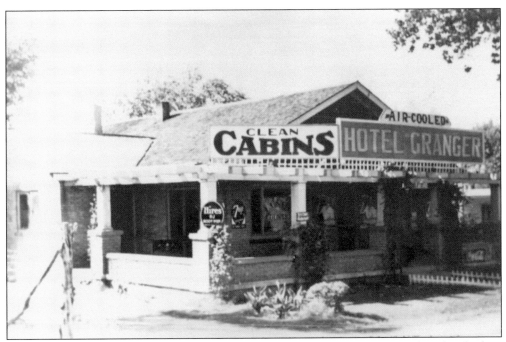

The Granger's Café and Rooms evolved into the Granger Hotel, advertising that they had air conditioning, Simmons beds, modern cabins, home cooked meals, and café service. The location for this business proved fortuitous as the Arrowhead Trail became Highway 91. Travelers could find many needed services after crossing long desolate stretches of roads.

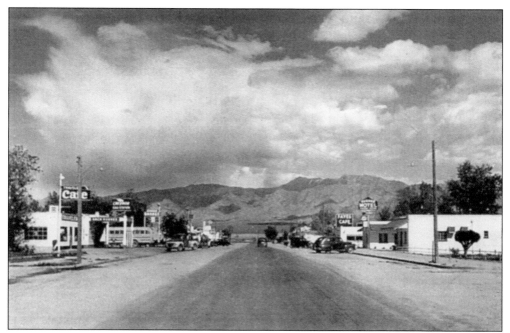

This Mesquite Boulevard postcard view from the 1940s shows the center of the business district of Mesquite. Highway 91 runs down the middle and is just a two-lane highway with gravel shoulders and asphalt sidewalks. The town seems to abruptly end in the distance, but the highway made a sharp left turn and proceeded on with more businesses.

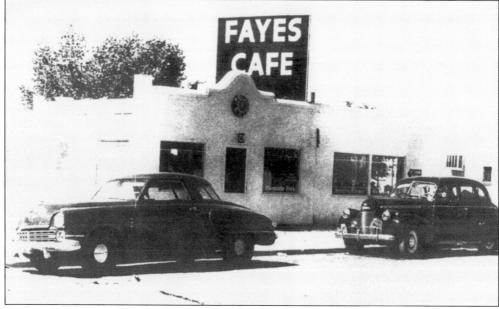

Fayes Café was built and owned by Faye and Nora Leavitt in Mesquite. Started in the 1940s, the business became a popular stop for travelers and locals. They lived in a home on the east side of the café with their five daughters, Peggy, Nedra, La Faye, Carolyn, and Claire. The whole family worked in the café, though Faye was sometimes away with outside jobs, and during World War II, Faye's absence forced the café to close. Nora eventually reopened and ran it alone.

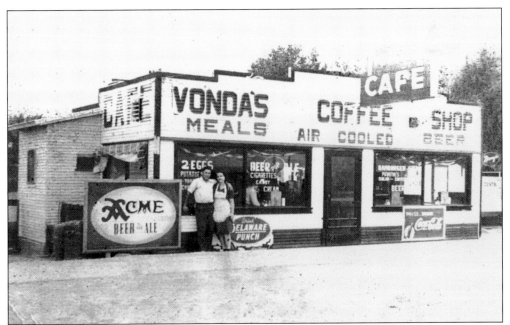

Joe Wilson started Vonda's Café, which was named after his wife, Vonda Hardy. It has always been the dominant business on the southern part of the big turn in Mesquite on Highway 91. It was later remodeled with an upstairs apartment, where Joe and Vonda lived and raised their family. The lower photograph was taken inside Vonda's Café in 1938 and shows four unidentified customers sitting in a booth, while standing are, from left to right, Nevada Pulsipher, Lorena Hardy, Vonda and Joe Wilson, Arlo Leavitt, and Lavern Hart. Slot machines can be seen to the right, as gambling was made legal in Nevada in 1931. Prices for served food are seen on the window above the customers.

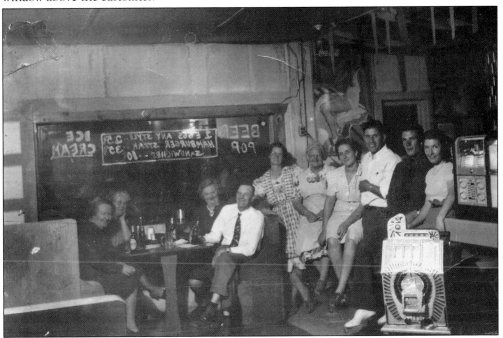

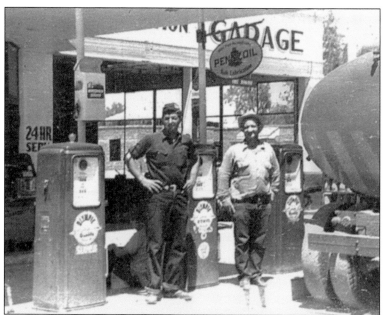

Don Lee (left) and Mark Hardy are shown standing in front of Don's service station in Mesquite. As seen in this photograph, he offered 24-hour service. Later Don's son, Bill, and his wife, Jessie Abbott Lee, owned the station and Vonda's Café across the street, which they had renamed Chalet Café, and lived in the Ganger Hotel, which had become a private residence.

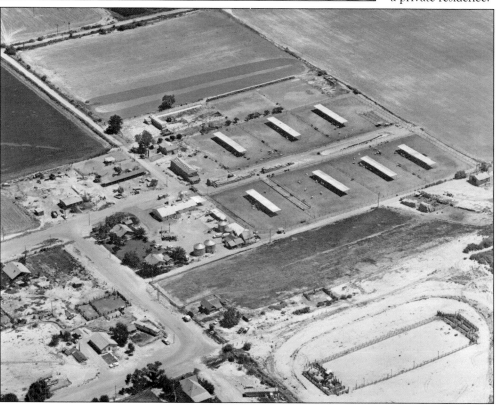

The C. A. Hughes and Sons Dairy is shown in this aerial photograph taken in the late 1960s. The father and sons worked as a unit sharing profits and dividing income as was needed by individual families. The business grew until the older generation began to retire, while the younger generation pursued other occupations. The land was later sold and developed into housing subdivisions.

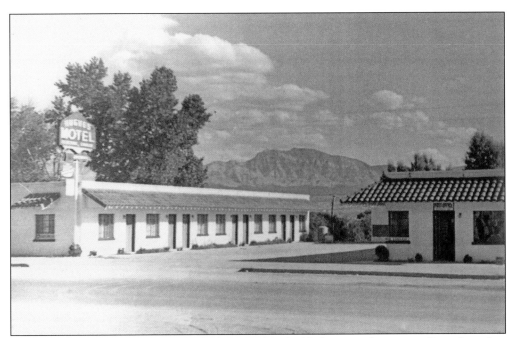

Elmer and Emily Abbott Hughes built this motel and added a space for a post office when they were awarded the mail contract in 1958. In this photograph, the back of the motel parking area is open, but later the Hughes family filled the space and added a home so they were always near their business.

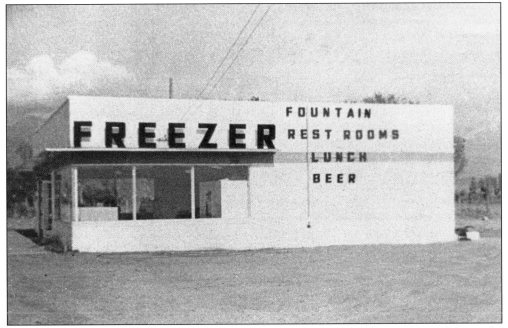

Paul and Gloria Grose built the Freezer Café in 1950. They also constructed a small home for themselves in the rear of their parking lot to the east. Mike Burns who used it to serve truckers who stopped at his Richfield Truck Stop across the street owned the building in later years. Maybe in the heat of summer "Freezer" had special appeal.

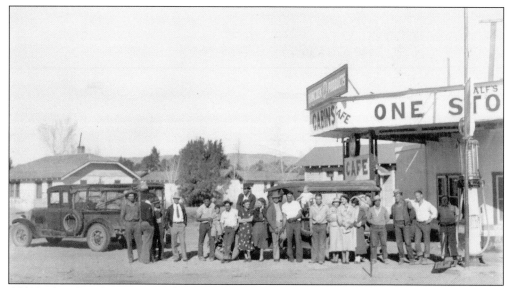

Alf Hardy's One Stop service shop offered gasoline, food, and beds, but travelers who rented cabins during the early years of auto tourism needed to be prepared to furnish their own linens, because cabins were rented with beds consisting of bare mattresses.

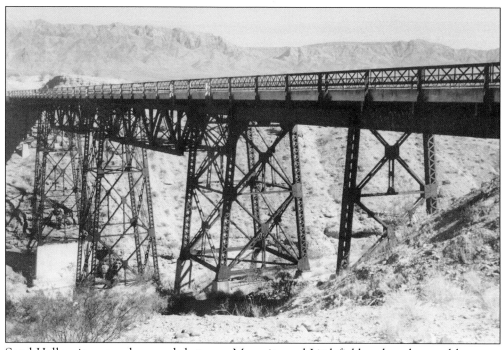

Sand Hollow is a very deep wash between Mesquite and Littlefield and made travel between the two towns very difficult until this bridge was constructed in the early 1940s. Even though Interstate 15 made this bridge obsolete, it is still maintained and traveled over by ranchers and school buses.

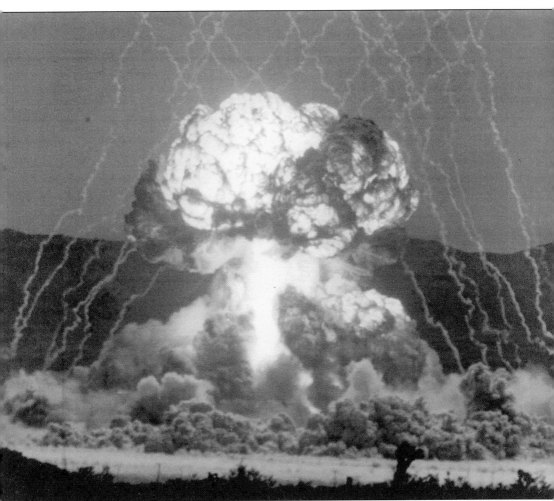

January 21, 1951, was the start of atomic testing in Nevada, and residents of the valley were excited to be able to see the most incredible display ever of the power of science. They watched as strangely colored clouds drifted overhead and left residue on automobiles, fields, and playgrounds. In 1955, two Atomic Energy officials spoke at a Virgin Valley High School assembly and acknowledged that the valley had the highest radioactive fallout in the nation but assured everyone that there was nothing to worry about. After one test, vehicles were stopped and washed, and families were sent home with instructions to stay indoors until notified. Years later, these "Down Winders" were acknowledged to be more in danger of cancer and other life-threatening conditions. It became a common practice for families to rise early, tune their radios to the countdown broadcast from the Yucca Flats Test Site, observe the incredible blinding light, and feel the rolling thundering boom as it ripped across the desert sky and hit the hills and mountains of the valley.

Until 1973, Highway 91, which is up the long slope from Beaver Dam to Utah Hill, was the only east bound route out of the valley. The long slow climb claimed many overheated radiators and spawned businesses that sold water to travelers. It made the hour-long trip to St. George seem even longer when there were medical emergencies. (Courtesy of Dorothy Thurston.)

Castle Cliff is at the far eastern end of the valley at the beginning of Utah Hill. The businesses at this place were a Shell service station on the cliff side of the road, which was owned by the Lowe brothers, and tourist cabins across the road. Cars coming from the west had just made a long climb to reach that point and had a steep climb ahead of them. At the cost of $1, you could buy enough water to fill a radiator.

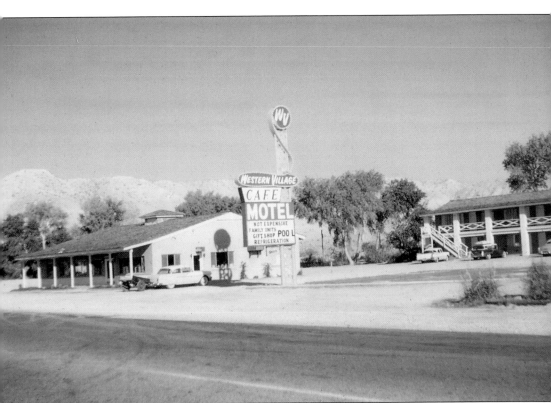

In 1959, brothers Lew and Bill Pulsipher started a project on family farm land at the western edge of Mesquite on Highway 91. These Mesquite natives had moved to Salt Lake City and started a business in the tourist industry. They believed in the future of serving the traveler and built a $500,000 complex to accommodate this new mobile public. In the photograph, part of the two-story, 22-room motel can be seen. In the center is the large restaurant and gift shop with the largest neon sign at the time in the valley. At the rear of the property can be seen old cottonwood trees that are growing along the still vitally important irrigation canal. As the tourism business in Mesquite grew and thrived, employment became more diversified, which meant more opportunities for work outside of agriculture became available. (Courtesy of Jerry Pulsipher.)

Oscar Abbott was also known as "Eagle Eye" because of his work as town sheriff and his ability to spot stolen cars. From 1941 to 1963, he patrolled the valley and busy Highway 91, which went right through Mesquite. During those years, he recovered more than 1,000 stolen vehicles and captured several "Most Wanted" criminals.

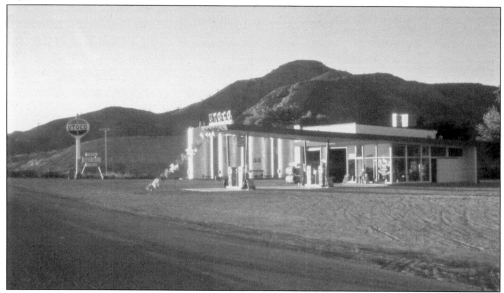

The Utoco Western Village service station also serviced diesel trucks, and a bunkhouse provided sleeping quarters for truck drivers. The whole Western Village complex provided many jobs, which were especially appreciated by college bound young people who would work summers and during school holidays. (Courtesy of Jerry Pulsipher.)

Five

Big Changes

It seemed to start with the same independent spirit of the early settlers and the notion that there had to be a better way of doing things. If the powers at the county seat wouldn't help us, we had to do it ourselves. The Mesquite Town Board decided that incorporation was necessary to gain control over the future of the town. After a lot of research and hard work, town board member Harley Leavitt and chamber of commerce representative Thelma Davis were able to rally forces to furnish the required signatures needed to petition the district court for incorporation. To the shock and skepticism of Clark County officials, Mesquite was declared a city in May of 1984. The first year was confusing, and the learning curve was very steep. Elections were held, and new city leaders had to learn their jobs fast while the county officials confidently waited for the failure of Mesquite. City council meetings became popular events as citizens watched and cheered on Mayor Jimmie Hughes and councilmen Craig Pulsipher, Bill Lee, and Dan Spencer while they worked through the challenges of governing a new city.

With growth clearly on the horizon, the new city government took control with a carefully thought-out master plan that has changed and been adapted through the years but has kept Mesquite from becoming an "accidental city." Golf courses began to spread across the landscape, and travelers started coming to stay instead of just passing through.

The explosive growth has presented challenges that are still being met. Out dated and out grown schools, churches, and city buildings have been replaced, and new shopping centers have opened. Homes are now spread throughout the once lonely sand hills, and streets now cross washes on modern bridges.

The early settlers were dreamers; however, could they have dreamed this?

Those sworn in as leaders in 1984 of the new city of Mesquite were Jimmie Hughes, Bill Lee, Craig Pulsipher, Dan Spencer, and district court judge Roy Guy. After Mesquite achieved its incorporation, the Nevada Legislature changed laws, and no town in the state has been able to become independent from a county commission since Mesquite.

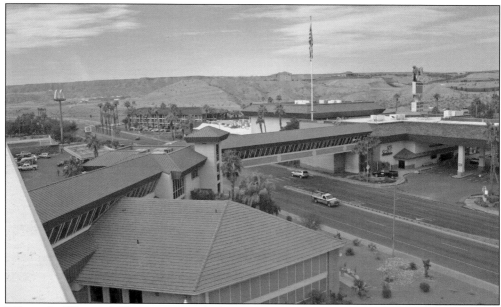

Where the Western Village once stood, the Oasis sprouted and grew into an expansive casino/ resort property. Others soon followed it, and there seemed to be no end in sight. The new city government was determined that growth would be carefully planned and controlled so that mistakes made during rapid growth in other Nevada towns would not be repeated in Mesquite. (Courtesy of Pete Clayton.)

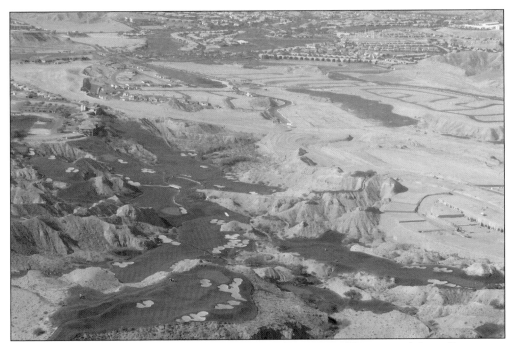

Tucked among the sand hills and along the river, the seven golf courses of the valley attract visitors to a green belt that is no longer made up of alfalfa fields or vineyards. The demand for water, caused by the booming growth, has resulted in use of river and reclaimed treated water to irrigate golf courses and supply the huge decorative waterfalls, saving water from the many wells in the valley for the culinary system. (Courtesy of David Bly.)

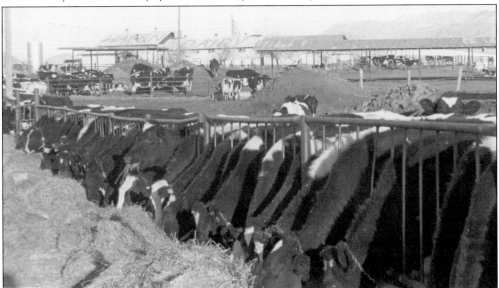

There are no dairies in the valley now, but at one time there were more dairy cattle than humans. The herds had approximately 1,100 cows and provided much of the milk for the Las Vegas area processors, such as Anderson Dairy and Knudson Dairy. This photograph shows the Hafen Dairy on the west edge of Mesquite in the 1970s that was started by Max Hafen and was continued by his son Bryan.

Where once the city was governed from a small community center that had come with the deal struck with Clark County at the time of incorporation, the local government is now headquartered in this large accommodating building in the heart of old Mesquite. On this same block is a modern Central Fire Station. (Courtesy of Pete Clayton.)

The rapid growth in the valley put a good deal of stress on the old school campus, which still housed kindergarten through the 12th grade. In this aerial photograph, the edge of the new Virgin Valley High School campus can be seen as it touches the Arizona state line. Through an agreement with the Mojave County School District in Arizona, students on that side of the state line were bused to Mesquite until growth required the building of a high school in Beaver Dam. (Courtesy of David Bly.)

For many years, shopping in Mesquite was restricted to a few general merchandise stores with limited inventory. Travel outside of town was required to obtain much beyond the basic necessities. In recent years, the opportunities for shopping have almost exploded with national "big box" stores coming to Mesquite. (Courtesy of Pete Clayton.)

Mesquite honored its founders with the placement of a statue of William E. Abbott and his wife, Mary, on the corner of Willow Street and Mesquite Boulevard, which is on the city hall block. The figure of Mary depicts her efforts as a midwife, and William's figure stands in tribute to his strong leadership. They represent and honor all the builders and dreamers who settled the valley. (Courtesy of Pete Clayton.)

The long-awaited link in the Interstate 15 system was completed and dedicated December 14, 1973, through the spectacularly scenic Virgin River Gorge in Arizona. At the time of its construction, it was considered the most expensive—$61 million for 29 miles. It was an incredible engineering feat for the rural interstate system. Construction crews encountered the same quicksand and flooding problems on the Virgin River that early settlers faced, but instead of losing teams and wagons, they lost huge pieces of equipment. In places, the canyon is only 150 feet wide with vertical rock walls extending 300 to 500 feet high and is set among 2,000-foot mountain peaks. Virgin Valley residents were relieved to have a safer faster route to reach St. George, Utah, and medical help. (Courtesy of Dorothy Thurston.)

For many years, the Latter-day Saints were the majority of the population in the valley, but recent growth has increased diversity in religious representation. Pictured above is the new Catholic church building. When the Bunkerville LDS chapel was replaced in 1991 by a new building, the Catholic diocese bought the old chapel and has used it for years. (Courtesy of Pete Clayton.)

This Methodist Church building is located on Pioneer Way and is a neighbor to the Lutheran Church with their child care center. Many other denominations are spread throughout the valley. All faiths in the valley work together for the good of all through thrift stores and food banks. (Courtesy of Pete Clayton.)

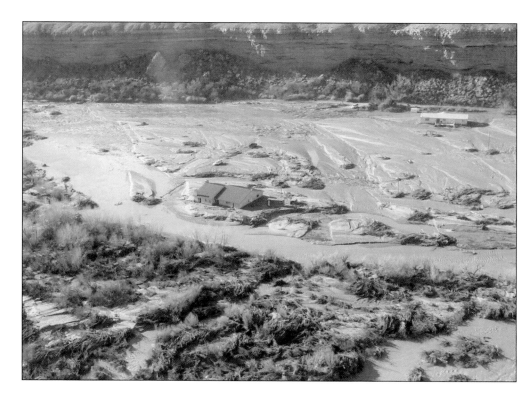

Floods continue to ravage the valley, as seen in these photographs taken January 2005 in Littlefield and Beaver Dam. Homes were marooned in a river of mud, showing how unpredictable and dangerous the river still is. Rains that melted heavy snow packs in the mountains of Southern Utah caused this flood, but there are other causes for floods. On New Year's Eve 1988, the earthen Quail Creek Dam near Hurricane, Utah, broke releasing the water of the reservoir and sending a flood that followed the Virgin River south, which devastated communities all along the way. For days, some roads were closed, bridges were washed out or made unstable, and homes and fields were lost as the river took portions of land. (Courtesy of Pete Clayton.)

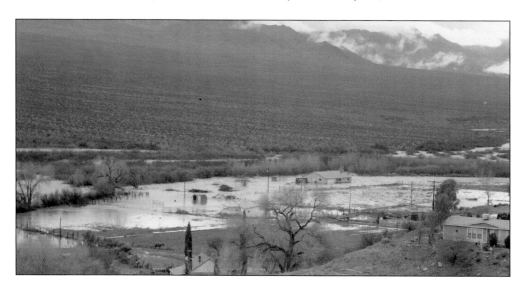

This area of Mesquite, which was always considered downtown, has gone through changes in recent years. Homes used to stand adjacent to businesses, and a field used to cover a large part of the block. The photograph above shows Mesquite Boulevard as a city street with planted median islands. Some businesses and homes from past years remain, but many have been repurposed or remain vacant. (Courtesy of Pete Clayton.)

Medical help has always been difficult to provide to the valley. For years, it was pretty much "every man for himself." When a volunteer ambulance service was created, the rushed trip to outside help occassionally still resulted in deaths and risky births. The new Mesa View Hospital and the arrival of many new doctors have made the care of valley residents much easier. (Courtesy of Pete Clayton.)

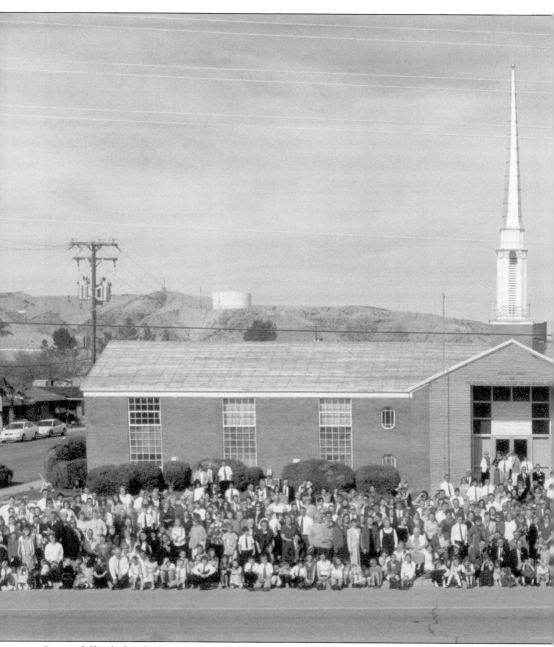

It was difficult for the many people who had helped construct the Mesquite Chapel in 1953 on Mesquite Boulevard to hear the news that the building was to be razed. Though the congregations that had attended church there had moved to the new buildings on North Arrowhead Street, many memories made the old chapel very special. In the fall of 2001, the Mesquite Nevada Stake

of the Church of Jesus Christ of Latter-day Saints gathered to have one last group photograph. The building was demolished soon after as many gathered to watch and pick up pieces of the rubble as remembrance. (Courtesy of Janet Dodenbier.)

This aerial photograph shows Mesquite as it was in 1968. Mesquite Boulevard was still Highway 91 and made a hard 90-degree turn to the north before sweeping east and climbing Linge Hill. There was no development north of the irrigation canal near where Interstate 15 would eventually run. Green fields still dominated the landscape, even near the center of town. Farm animals shared property with homes, and ditches still ran through town. There was one school, kindergarten through the 12th grade, and one church, and Mesquite's population was less than 600.

This 2010 aerial photograph shows Mesquite as it extends into the once-barren sand hills. The north of Mesquite is intersected by Interstate 15 with golf courses, casino/hotel resorts, shopping centers, and many housing developments, some of which go south to the edge of the Virgin River flood plain. Mesquite is bounded on the east by the Arizona state line and on the south by the Virgin River. With land acquisitions from the Bureau of Land Management, development has continued north to the Lincoln County line and west to the base of Flat Top and Mormon Mesas. Open spaces are no longer fields with crops but public parks and athletic fields. There is still the 90-degree turn in the highway, which is now governed by a traffic light. (Courtesy of Rob Faught and John Zarate.)